# LITTLE BOOK OF

# LETTER PRESS

**CHARLOTTE RIVERS** ● **FOREWORD BY YEE-HAW INDUSTRIES**

CHRONICLE BOOKS
SAN FRANCISCO

Library of Congress Cataloging-in-Publication Data available.

ISBN: 978-0-8118-7507-3

Manufactured in China

Cover design: Eloise Leigh
Art director: Tony Seddon
Design and layout: Lisa Båtsvik-Miller
Editor: Diane Leyman
Typeset in Clarendon, Mrs Eaves and Rosewood

Published and distributed outside of North America by RotoVision SA.
Route Suisse 9
CH-1295 Mies
Switzerland

10 9 8 7 6 5 4 3 2 1

Chronicle Books LLC
680 Second Street
San Francisco, CA 94107

www.chroniclebooks.com

# Contents

# Foreword

To a young printer who has set type and run presses for the past ten years on a near-daily basis, the recent revival and continual rise in the practice of letterpress printing comes as no surprise. With its rich worldwide history and endless catalog of equipment, one would be hard pressed to become a complete expert on the form. While letterpress was the definitive periodical and book printing process for centuries, so-called advances in printing technology caused it to all but disappear by the late 1950s from the mainstream in the shadow of offset lithography. Eventually the computer came into the picture, shifting turnaround times into an even higher gear. What had once taken days to set up and print was now achievable in a few hours, and this new method therefore became the industry standard for printed materials. But something was lost.

Letterpress equipment was moved to the barns and basements of the world to clear space on print shop floors for newer time- and space-saving machines. Large printing houses sold their type for scrap prices. There were tales of printers making bullets by way of melting ornate lead fonts, or keeping themselves warm in the winters by burning beautiful wood type. Antique collectors dumped drawers of metal type, hanging them on the walls as a way of displaying their thimble collections. Eventually, museums began housing type and press collections that were rarely on view to the public, as they were seen as a more recent part of history that had not yet become very intriguing. The future of letterpress printing looked grim at best—it had lost favor with printers as an efficient way to get the job done.

Those who chose to employ this now-dated process were often viewed as "luddites" or "dinosaurs."

Among these printers were those to whom modern letterpress operators owe a great debt of gratitude. These craftspeople saw the underlying value and beauty in the old ways, and fought to collect and preserve the equipment that made them possible. Many were of the opinion that these new forms of quick printing eliminated the hand-crafted element and attention to detail required by the more traditional methods. When handed a print produced by way of the letterpress process, one is immediately drawn to its tactility and dimensionality, while at the same time becoming aware that it is not just a piece of paper but a three-dimensional object. The recipient cannot only see the type, but can often physically feel the letterforms while handling the print. Most would agree that this is the basis of the modern fascination with letterpress printing, but this wasn't always so.

Letterpress printers of old painstakingly avoided this deep impression for fear of damaging their type and equipment, and this remains a concern for modern printers who carry the historical torch of carving blocks and setting type by hand. The computer-aided convention of water wash polymer plates has allowed for printing with a herculean level of pressure, eliminating the issue of damage to type and block. While both methods are relief-based processes, traditional letterpress practices deal more directly with the printers' measure of the point and pica system and the raw, physically composed typographic form. The real rigor lies in the set up

and preparation of the form as opposed to the printing thereof. Often faced with making decisions based on the availability of type characters and images in a collection, the traditional printer does not necessarily enjoy the limitless archive of digital and scanned imagery available to the computer-aided designer. Original type forms have gradually become less pure and accurate due to their being repeatedly photographed or scanned, and digitally rendered and stretched typefaces not designed specifically for letterpress printing have now been thrown into the mix.

As the line between type and image becomes blurred due to new methods of design and printing technology, it seems that the definition of the term "letterpress" continues to broaden and change at an almost daily rate. This book provides a look at where letterpress stands in the modern world, ever changing and constantly garnering attention for its unique history and distinct characteristics.

**Adam Hickman Ewing**
**Yee-Haw Industries**
**Knoxville, Tennessee, USA**

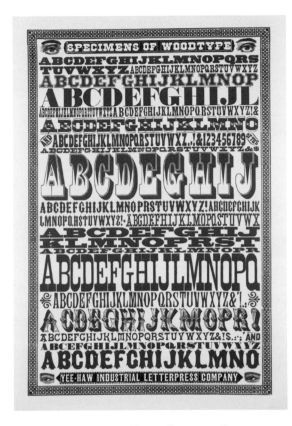

**Above:** *This 32 x 40in/81 x 101cm hand-pulled letterpress print showcases select examples from the Yee-Haw Industries antique wood type collection, including Tuscan Inline, Bodoni, French Clarendon, Aldine Ornamented, and Tuscan Expanded. It was printed in red and black inks on 100 percent cotton paper with deckled edges.*

# A Short History

Having fallen out of favor for many years, letterpress printing is currently enjoying a revival, as creatives of all stripes rediscover its unique qualities. From greeting cards and posters to calendars and wedding invitations, letterpress taps into today's ever-popular handmade aesthetic. No two prints are exactly the same—each is subtly different. The artistic opportunities offered by this most traditional of printing techniques are many and varied, and the results are quite simply beautiful.

Letterpress is a term used to describe the relief printing of text and/or images using a press with a type-high bed. The concept of relief printing from carved wooden blocks is thought to date back to before AD c. 200 in China. However, it is German Johannes Gutenberg that is generally regarded as the pioneer of printing with reusable, movable type. In the mid-fifteenth century he invented the use of individually cast, movable letters, which replaced handwritten calligraphy. The famous Gutenberg Bible published in c. 1455 established Gutenberg's movable-type invention as a superior means of printing. As well as movable type, Gutenberg adapted the screw mechanism, more commonly used in wine making, to develop his first wooden handpress. This worked by inking the type surface, placing the paper on top by hand, and then sliding it under a padded surface, before using the threaded mechanism to apply pressure and make an impression. As the process developed, presses that used a knuckle and lever mechanism were designed, and ink rollers slowly came into use. The paper on these platen presses was still placed by hand, but the rollers did the inking. Once the ink had been applied to the rollers they would swing back onto an inking plate to collect more ink. In the meantime, the platen was pressed onto the paper to create the print, the printed paper was removed from the press and replaced with a fresh sheet of paper, and the process was repeated. By the twentieth century, presses such as the Kluge and Heidelberg Windmill featured automated feed and delivery. Gutenberg's press processes remained unchanged for over three hundred years, and floor-standing hand-operated platen presses

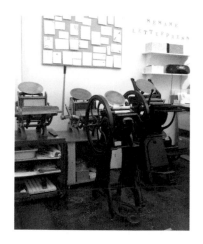

were direct descendents of the Gutenberg. In the mid-nineteenth century the Industrial Revolution and improvements in engineering saw the creation of a huge number of handpresses. These new presses attempted to improve on the weighting and leverage needed to create an imprint, and are still widely used by hobby printers and small stationery companies today. Popular models include the Chandler & Price and the Adana 8 x 5, the latter of which was produced in England until 1999.

Toward the end of the nineteenth century, full-sized platen presses, including the Chandler & Price and Golding Jobber, were also being manufactured and were used mostly for commercial printing up until the end of the twentieth century. Over the years they were modified and automatic feeds were added, the best known being the Heidelberg Windmill press, which is still a popular automated press used by commercial letterpress printers today. By the 1930s, motorized flatbed cylinder presses such as the Heidelberg KSBA were also becoming popular among commercial printers owing to their ability to handle large print runs.

**Left:** *A selection of tabletop and platen presses from the Sesame Letterpress studio (see pages 38–39).*
**Right:** *An Original Heidelberg press from the Delphine Press studio (see pages 138–139).*

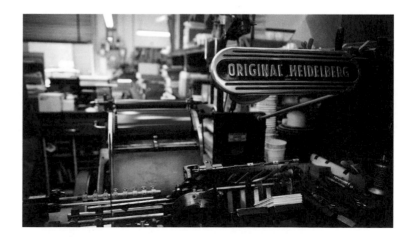

By the 1960s the development of offset lithography—a printing technique where the inked image is transferred from a plate to a rubber cylinder and then to the printing surface—completely changed the nature of the printing industry. Letterpress became economically unviable and found itself, for the most part, redundant. Printers cast aside letterpress machines, and many were sadly sent for scrap. Although some letterpress studios continued to operate they were few and far between and were largely high-end, specialized printers or hobbyists. The letterpress industry was somewhat revolutionized, however, by the introduction of photopolymer plates, which have become a popular choice for letterpress printers owing to their cost-effectiveness and ability to produce excellent results. Photopolymer plates can be created from either a digital file or hard copy and they are made by converting the typography or artwork into thermal negative film before exposing it to a UV photosensitive photopolymer plate. The UV cross-links the polymers and hardens the negative image and the unexposed portion of the plate is gently washed off with water, leaving the hardened raised text or image. The plates are then adhered to a (usually metal) base to make them type-high. Of course, there are those who say photopolymer plates will never quite match the printing quality of metal plates, but there is no denying that they work incredibly well, and their accessibility makes them the preferred choice for many of today's professional and hobbyist printers.

Since the 1990s there has been a significant rise in the number of individuals and small companies starting up shop and producing letterpress materials—predominantly in the United States and United Kingdom, but also in Australia, Canada, and many other countries around the world. Collectively, these individuals and studios have revived the fortunes of letterpress printing. Presses that would once have been destined for scrap were, and still are, being bought and restored by letterpress enthusiasts, and once again the craft of letterpress has become the printing method of choice. It is a discipline that is both loved for its history and tradition and valued for the time, care, and effort the printing method requires.

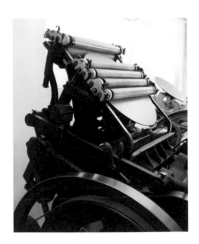

Letterpress began as a form of communication for the masses via books, broadsides, manuals, and newspapers. When it was first invented, letterpress printing was all about making a "kiss" impression—a light impression on the paper—however it is far more favorable today to create a deep impression when printing. The tactile nature of a deep-inked impression on soft cotton stock is what is so loved by letterpress printers and their clients. Pressed letters and images have a wonderfully crisp and sharp look on paper that is both distinctive and elegant, not to mention unique. This book celebrates all forms of modern letterpress printing and brings this traditional discipline into a modern context.

**Left:** *A Kluge press from the SeeSaw Designs studio (see pages 22–23).*

**Right:** *Julie Dutton at work in the Studio Olivine studio (see page 81).*

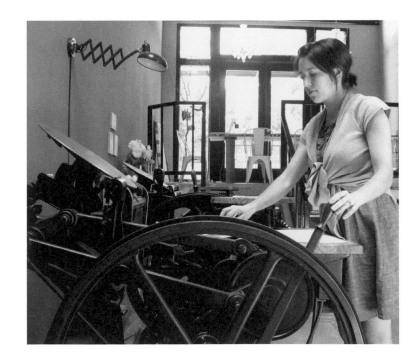

# Letterpress In Practice

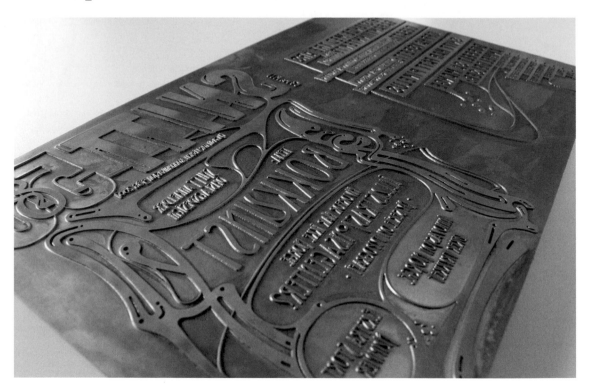

## Creating your design

The first step of the letterpress process is to create a design. While some letterpress pieces are entirely type-driven using wood or metal type, much modern letterpress printing involves artwork. Artwork can be created digitally, or original hand-drawn images can be scanned and cleaned up digitally. All artwork is then converted into black and white and transferred to a plate ready for printing. Hand-carved linoleum blocks can also be directly printed from.

**Above:** *A plate ready for printing, from Skin Designstudio (see pages 52–53).*

**Right:**

*Top left: a linoleum block from Blackbird Letterpress (see pages 62–63).*
*Top right: preparing artwork digitally, from Delphine Press (see pages 138–139).*
*Middle left and right: wood type and blocks from Yee-Haw Industries (see pages 56–57).*
*Bottom Left: photopolymer plates from Dawn Hylon Lucas (see page 59).*
*Bottom right: metal plates, from BirdDog Press (see pages 50–51).*

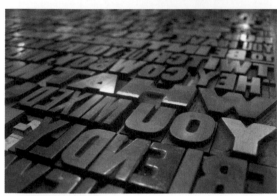

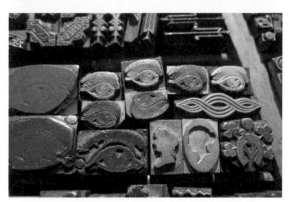

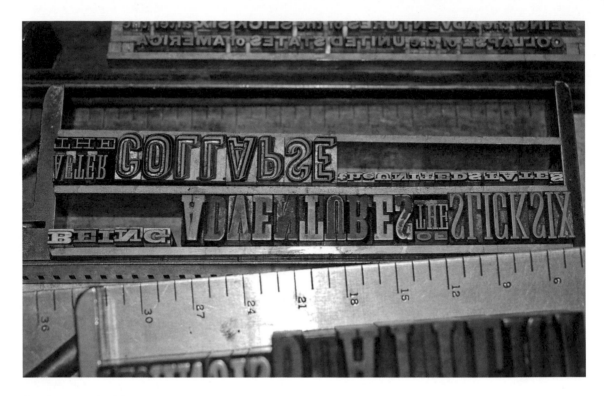

## Setting and locking

In traditional letterpress printing, individual movable letters and blocks are assembled in a frame known as a chase (see above). Each item is spaced using less than type-high wooden or metal blocks, and everything is locked into place using quoins. In the case of plates (photopolymer, zinc, magnesium, or copper), these are mounted on a metal base to make them type-high. One plate is created for each pass of color on a particular piece.

**Above:** *Letters assembled in a chase, from Ross MacDonald (see page 90).*
**Right:**
*Top left: type case, from Typoretum (see page 111).*
*Top right: leading from the London College of Communication (LCC) letterpress studio, taken by Eric Eng (see page 91).*
*Middle left: composing stick, from Blackbird Letterpress (see pages 62–63).*
*Middle right: letterpress furniture from the LCC studio, taken by Eric Eng (see page 91).*
*Bottom left: wood type set in a chase, from The Paper Thieves (see page 102).*
*Bottom right: letters and blocks assembled in a chase, from Jens Jørgen Hansen (see pages 112–113).*

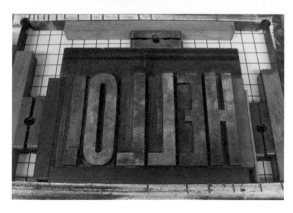
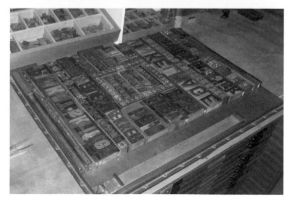

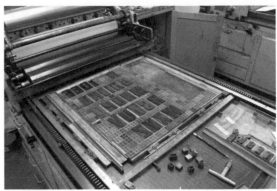

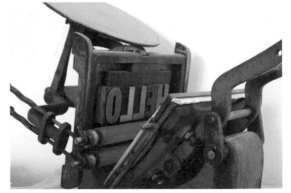

## Inking and printing

There are many different letterpress inks available, but the most popular are water-soluble rubber-based inks and soy-based inks. These can be used straight from the tin or can be mixed by hand with other inks to create different colors. Amazingly, just a spoonful of ink is enough to print a thousand or more greeting cards. Once the ink is ready it is applied to the rollers, which then move over the handset type or plate, applying a layer of ink to the text or image. Paper is then fed into the machine, either automatically or by hand, and the reversed type or plate is pressed onto the paper to create a positive impression. The paper is then removed and allowed to dry.

## The finished piece

Each printed piece is checked for smudges, ink splashes, and so on. Once approved, the piece is dried before being trimmed and packed, ready to be sent off to the client.

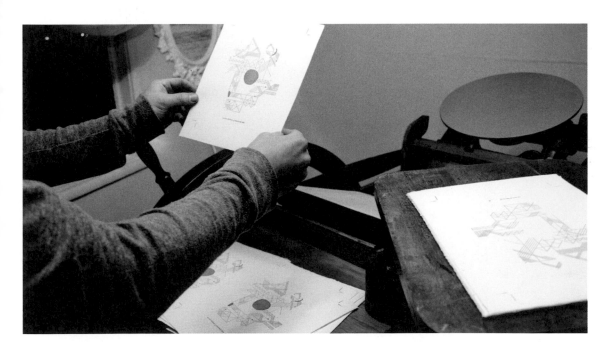

Letterpress Portfolios

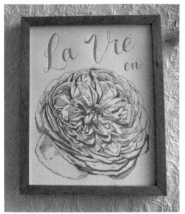

## Sycamore Street Press
Heber City, Utah, USA

Shown here are a number of pieces printed by Sycamore Street Press in collaboration with various designers. The print and two cards shown right were created by Eva Jorgensen using scanned, hand-drawn illustrations that were made into polymer plates and printed using a Vandercook No. 3 proof press with soy-based inks and Crane's Lettra cotton stock. The ABC and 123 posters (above and far right) were designed by Stephanie Ford in collaboration with Sycamore Street Press. They were designed in Illustrator, turned into photopolymer plates by Boxcar Press, and also printed on a Vandercook No. 3 Proof Press.

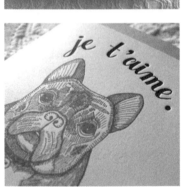

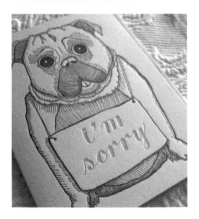

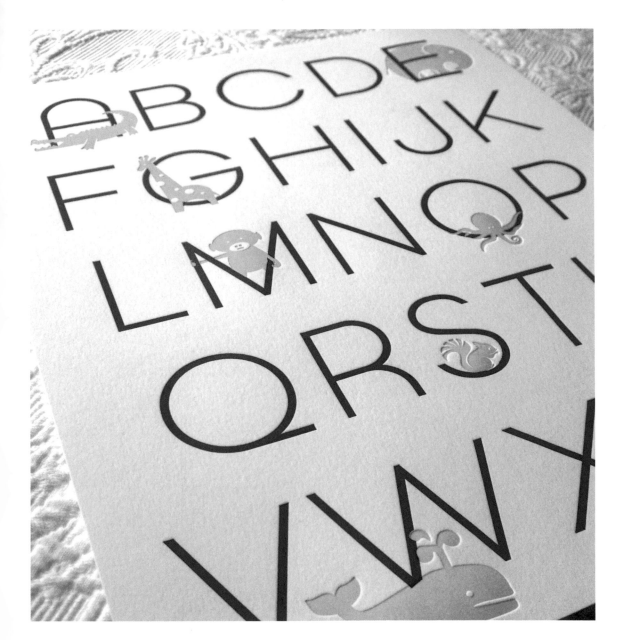

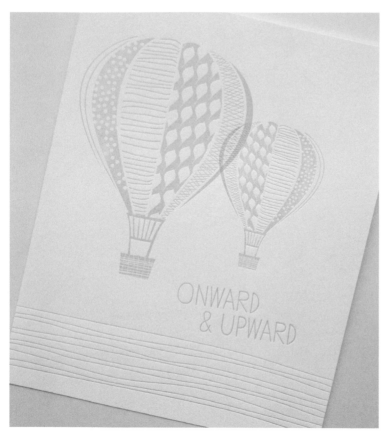

# SeeSaw Designs
## Scottsdale, Arizona, USA

The hot air balloon limited-edition print (above and right) was made using a Kluge press with photopolymer plates, Van Son inks, and Crane's Lettra cotton stock. The illustration on the wedding invitation (far right) was originally created by Trent Morue of SeeSaw Designs using bamboo pens and inks and was then traced in Illustrator, turned into a photopolymer plate, and printed using a Kluge press.

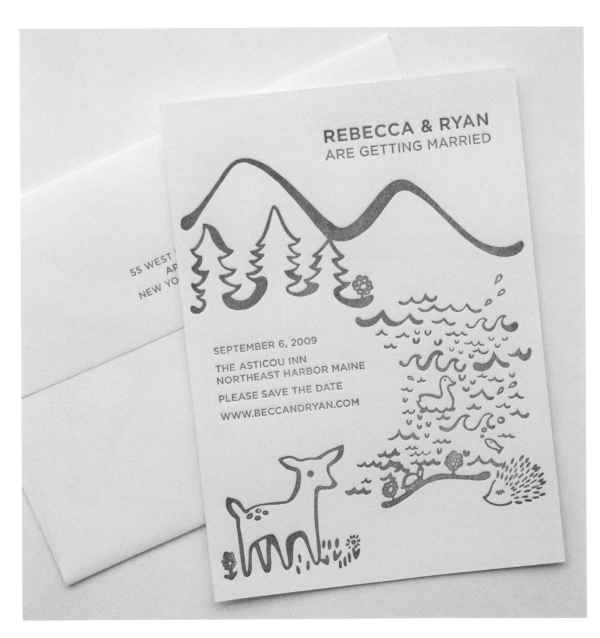

# Megan Creates

Westford, Massachusetts, USA

Megan Carty originally created this wedding invitation for generic use, but personalized it for this particular wedding suite. "I wanted to create a design that was sophisticated but unique enough to make a memorable impression," explains Carty. The invite was printed on a 7 x 11 Golding Improved Pearl press using Crane's Lettra Pearl White cotton stock.

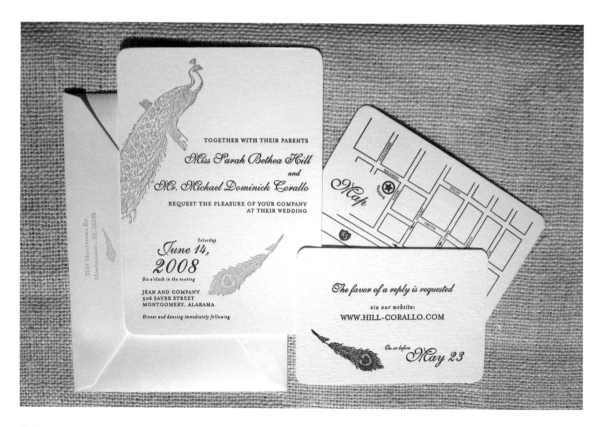

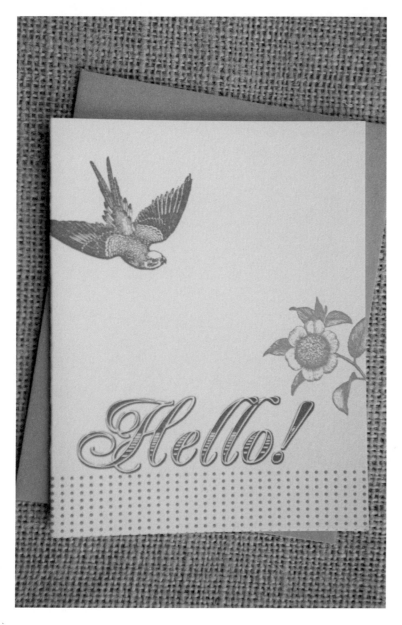

## Hello!Lucky
### San Francisco, California, USA

Illustrator Kate Sutton created the card shown below in collaboration with Hello!Lucky. She explains: "Hello!Lucky wanted me to come up with a Valentine's card involving a globe and a little bird lost in a boat. I was very excited about doing this card as I love old maps and wanted to try and re-create this in my drawing." The greeting card shown left was inspired by vintage clip art and circus graphics and was printed on a Heidelberg Windmill press using photopolymer plates and Coronado SST stock.

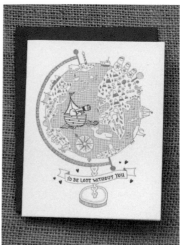

# Dutch Door Press

San Francisco,
California, USA

The cards and prints shown here
were designed and printed by Anna
Branning and Mara Murphy of
Dutch Door Press. The calendar
(middle) was inspired by vintage
tea towel designs. The Wildflower
Windmill print (far right, top) is
a limited-edition print inspired by
Dutch graphics, and the bear print
(far right, bottom) was originally
created as part of a fundraising
exhibition to benefit an art center
for special-needs adults. All of the
prints were created on a Vandercook
press using cotton paper stock. The
two cards shown right are part of
the Dutch Door Press collection,
and were printed on a Chandler
& Price press using Stonehenge
paper stock.

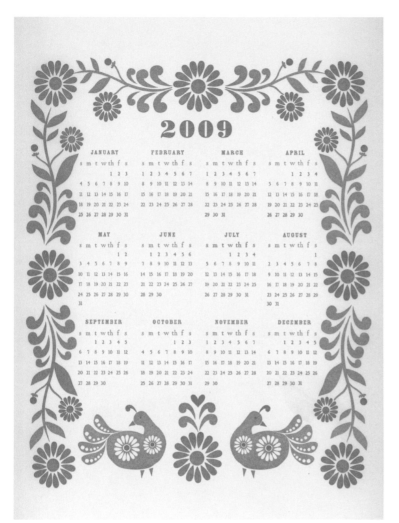

## Sarah Drake
## Design /
## Rohner
## Letterpress

Chicago, Illinois, USA

Inspired by botanical imagery,
this wedding suite was designed
by Sarah Drake and printed by
Rohner Letterpress (see also
pages 84–85 and 182–183).
The illustrations were created
in Illustrator and the suites were
printed on a Heidelberg Windmill
press using photopolymer plates.

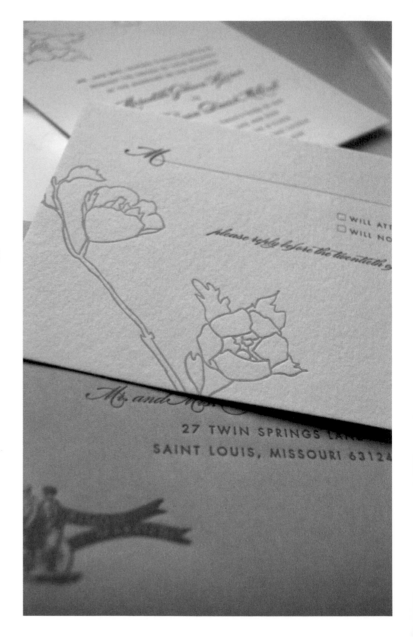

# May Day Studio
## Montpelier, Vermont, USA

Shown here is one of the cards from May Day Studio's Last Words series.
"I designed this line to fill a gap between blank cards and overly specific
event-focused cards," explains Kelly McMahon of May Day Studio.
This card was created from wood type and three different kinds of metal
decorative borders. It was run through a Chandler & Price press three
times, and was printed on French Paper Company Construction
Whitewash stock using hand-mixed inks.

# Thoughtful Day
## New York, New York, USA

Erica Miller of Thoughtful Day designed these wedding suites. The suite shown right was created for a couple who wanted a sophisticated invitation that incorporated fun details from the bride's hometown of Lewisburg, Pennsylvania. All of the illustrations were hand-drawn and transferred to Illustrator. The type was set in Illustrator and an existing font was modified to fit with the theme of the invitation for the invite and RSVP cards. The wedding suite below combines the client's love of folk art, floral patterns, and whimsical script. The repeat pattern was hand-drawn and then developed in Illustrator, and the couple's initials were selectively placed within the pattern on the back of the invite. Both wedding suites were printed on a Vandercook press.

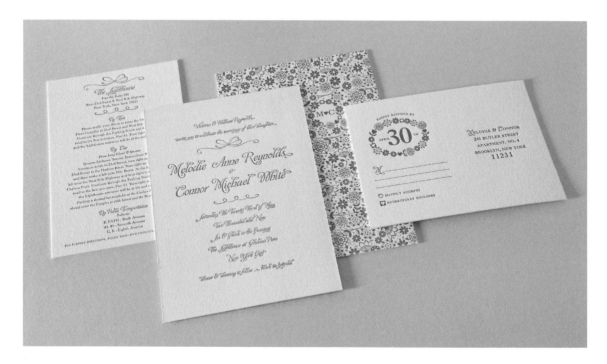

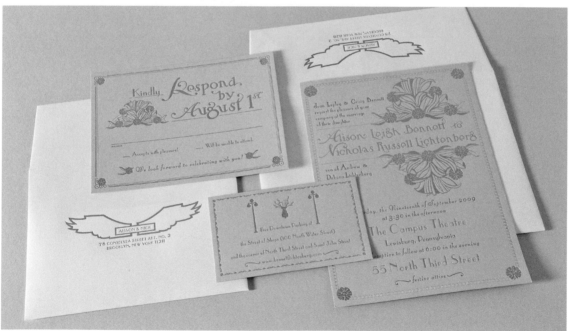

# Egg Press
## Portland, Oregon, USA

Shown here are a number of die-cut greeting cards from the Egg Press collection. They were created using computer-drawn elements combined with typeset messages, and were printed on Vandercook proof and Chandler & Price presses using Van Son rubber-based inks and Mohawk Superfine Ultra White stock.

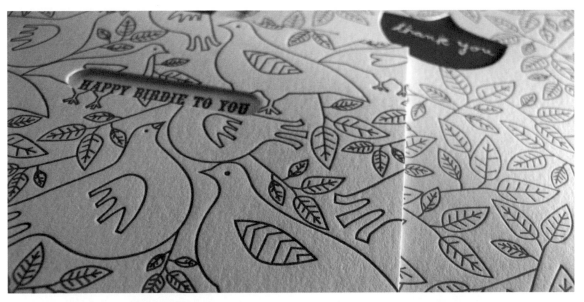

# Smock

## Syracuse, New York, USA

"Our stationery is inspired by our love for the earth and our passion
for design. We are a truly environmental letterpress company, printing
on pesticide-free bamboo paper," explains Cynthia Converse of Smock.
Shown below are two greeting cards from Smock's Everyday stationery
collection. Both cards were printed on a Heidelberg Windmill press
using photopolymer plates.

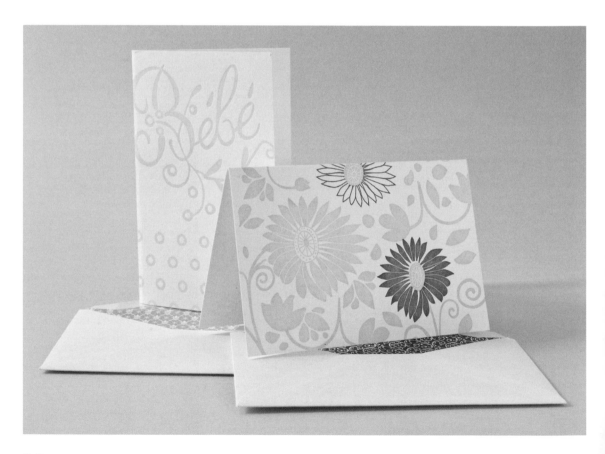

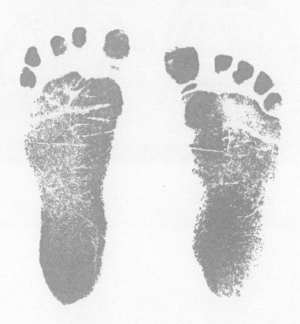

WE JOYFULLY ANNOUNCE
THE BIRTH OF OUR DAUGHTER

MIT GROSSER FREUDE GEBEN WIR DIE
GERBURT UNSERER TOCHTER BEKANNT

ELEANOR ALEXANDRA WARD GRÄFIN VON ARNIM
20 MAY 2009

JOLIE AND MAX

# Carrot & Stick Press

Oakland,
California, USA

This birth announcement was designed and printed by Carrot & Stick Press. It was printed in both English and German, and the footprints were taken directly from the baby's feet using an ink stamp, which was then scanned and set within the card design in Illustrator. It was printed on a Vandercook No. 4 press using Crane's Pearl White stock.

# Hammerpress

## Kansas City, Missouri, USA

Brady Vest of Hammerpress designed the pieces shown here. The bicycle postcard (right) was produced for the press's stationery line. The poster (below right and far right) was produced to promote a live show for musician Beck. "We created the large type forms on this poster by setting thousands of tiny lead ornaments by hand," explains Vest. "The design is quite simple and basic, but what makes this piece interesting is all of the intricate detail work." The poster was printed in three colors on a Vandercook press.

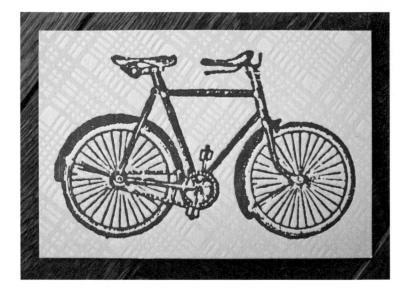

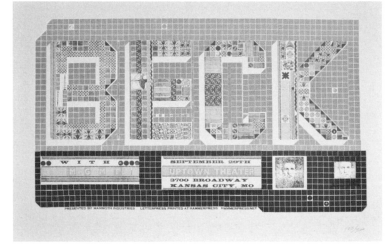

# Sesame Letterpress
New York, New York, USA

The Sesame Letterpress owners created the birthday party invitation shown below for their daughter and her friend. "We used a silhouette of Greta for her birth announcement and decided to continue this with her birthday party invitations as a way to chart her growth," explains Breck Hostetter of Sesame Press. "Greta wanted to art-direct the design of the invitation. She chose the colors and decided she wanted to be blowing bubbles while her pal Isabel waved a magic wand." The invites were printed on a Golding Jobber press and the silhouettes were double-inked with Van Son rubber-based inks to create a solid impression.

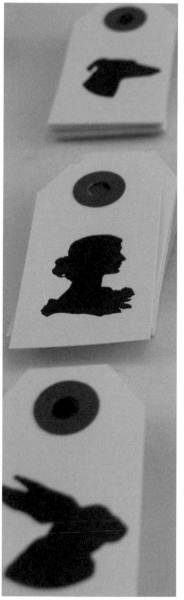

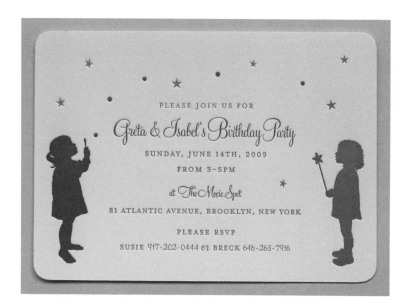

The series of gift tags (left) were created with family in mind. "We wanted to create gift tags for every type of family member," explains Hostetter. The majority of the images featured on the tags are from the Victorian era. They were printed on a Golding Jobber press, and each was double-printed to achieve a rich, solid black effect.

The coasters (top right) were designed in Illustrator using a Chevalier Stripes font and were then printed on a Golding Jobber press using card stock and rubber-based inks.

The gift tags (bottom right) feature a series of nineteenth-century etchings. "We like the idea of taking ready-made office supplies (like these tags) and running them through our presses with brightly colored inks," explains Hostetter. The tags were printed using photopolymer plates on a Golding Jobber press with Van Son rubber-based inks.

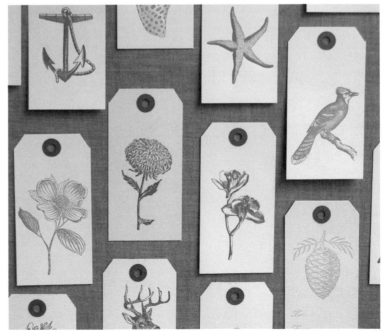

# Lucky Star Press
## Lexington, Kentucky, USA

Sarah Erdmann of Lucky Star Press created the thank-you greeting card
below for the company's spring 2009 line. It was printed by DeFrance
Printing, California, on Teton Tiara card stock. The other letter cards
shown here are part of a monogram collection. The designs were
formatted in Illustrator and then sent to a plate maker to create wood-
mounted magnesium plates. The cards were printed using a Chandler
& Price press with rubber-based inks on Teton Tiara card stock.

**40**

# Messenger Bird Press
## Brooklyn, New York, USA

Kelly Hands of Messenger Bird Press created the Mother's Day
card shown right in Illustrator, and Boxcar Press then transferred the
design onto photopolymer plates. The card was printed on 100 percent
cotton stock using a Vandercook press. Hands created a whimsical
monster character that was youthful, playful, and modern for the
birthday invitation shown below. The card was printed on a Chandler
& Price Pilot press using hand-mixed rubber-based inks and Crane's
Fluorescent White Lettra stock.

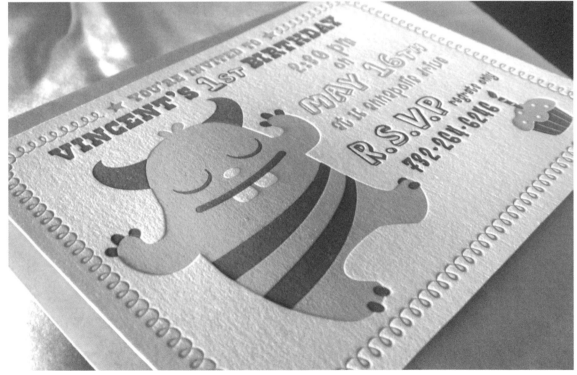

# Letters Lubell / The Mandate Press

New York, New York / Salt Lake City, Utah, USA

Shown here are a number of pieces designed by Kacy Lubell and printed
by The Mandate Press using a Vandercook press with photopolymer plates.
The card shown below left was created as a bridal shower gift and features
the Burgues Script typeface. The card shown below right was created as
an engagement gift and features a hand-drawn feather illustration and
the bride-to-be's married name. Cowboys, Utah, mountains, and deer
were the inspiration behind the wedding suite (right). It also features
the Burgues Script typeface, and the hearts, deer antlers, and horseshoes
were drawn by hand.

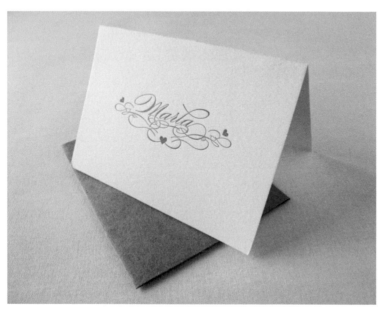

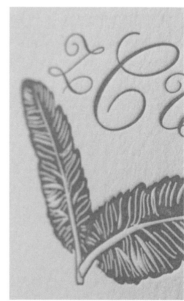

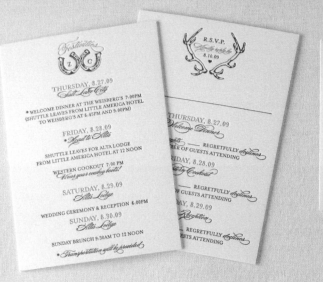

**Festivities**
Z C

THURSDAY, 8.27.09
*Salt Lake City*
• WELCOME DINNER AT THE WEISBERG'S 7.00PM
(SHUTTLE LEAVES FROM LITTLE AMERICA HOTEL
TO WEISBERG'S AT 6.45PM AND 9.00PM)

FRIDAY, 8.28.09
*Head to Alta*
SHUTTLE LEAVES FOR ALTA LODGE
FROM LITTLE AMERICA HOTEL AT 12 NOON

WESTERN COOKOUT 7.00 PM
*Wear your cowboy boots!*

SATURDAY, 8.29.09
*Alta Lodge*
WEDDING CEREMONY & RECEPTION 6.00PM

SUNDAY, 8.30.09
*Alta Lodge*
SUNDAY BRUNCH 9.30AM to 12 NOON

• *Transportation will be provided.*

R.S.V.P.
*Kindly reply by*
8.10.09

THURSDAY, 8.27.09
*Welcome Dinner*
_____ REGRETFULLY *declines*
_____ OF GUESTS ATTENDING

FRIDAY, 8.28.09
*Daily Cookout*
_____ REGRETFULLY *declines*
_____ OF GUESTS ATTENDING

SATURDAY, 8.29.09
*Reception*
_____ REGRETFULLY *declines*
_____ OF GUESTS ATTENDING

♥ WEISBERG ♥
754 NORTH HILLTOP ROAD
*Salt Lake City, Utah 84103*

*Will you be my*
*Bridesmaid?*

♥ 444 EAST FIFTY SECOND STREET ♥
APARTMENT 3D
*New York City, New York 10022*

PAM AND JON WEISBERG
REQUEST THE PLEASURE OF YOUR COMPANY

♥ *at the marriage of their daughter* ♥

*Zoe Buff*

TO

*Christopher Joseph Coady*

SATURDAY, THE TWENTY NINTH OF AUGUST
*Two Thousand and Nine*
AT SIX O'CLOCK IN THE EVENING

*Alta Lodge*
ALTA, UTAH

DINNER *and* DANCING
*to follow*

*Mountain Chic Attire*

# Pearl & Marmalade
## Chicago, Illinois, USA

The pieces shown here were designed in InDesign and then printed on an automatic platen press using Mohawk Superfine stock. The numbers print below was designed for children, and the art print shown top right was printed in brown and magenta inks. The series of cards shown below right was designed using manipulated copyright-free images.

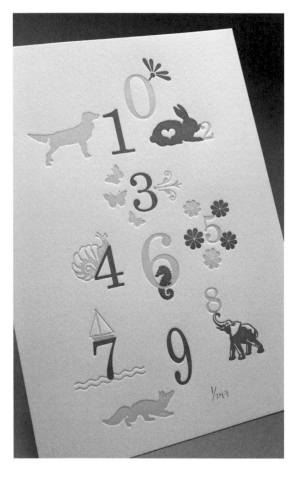

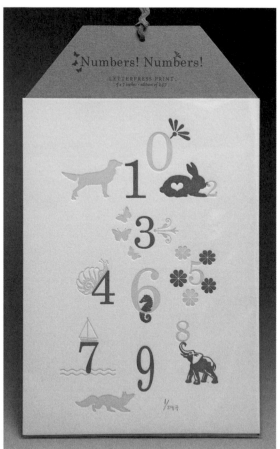

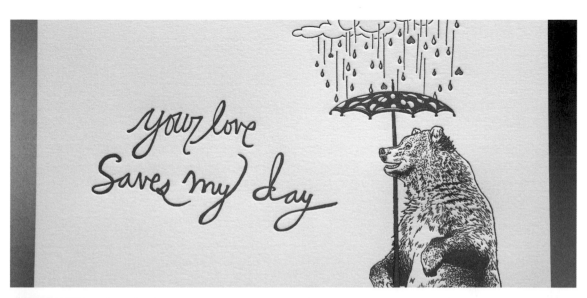

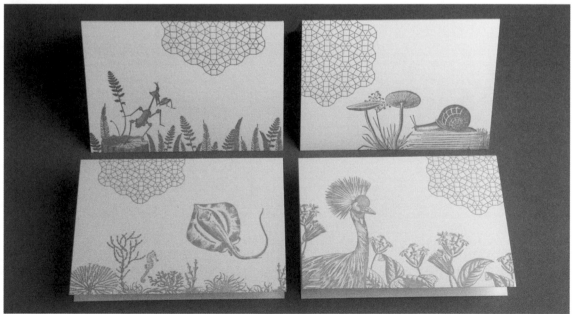

# Matthew Kelsey

Saratoga, California, USA

Printer Matthew Kelsey designed the wedding invitation shown here.
The client chose a favorite illustration as the main focus. The artwork,
created by Sudi McCollum, shows two hearts overlapping surrounded
by flowers and a bird in flight. The illustration was printed first, followed
by the text on the reverse side of duplex Crane's Lettra cotton stock.
It was printed on a 10 x 15 Challenge Gordon platen press using five
custom-mixed inks.

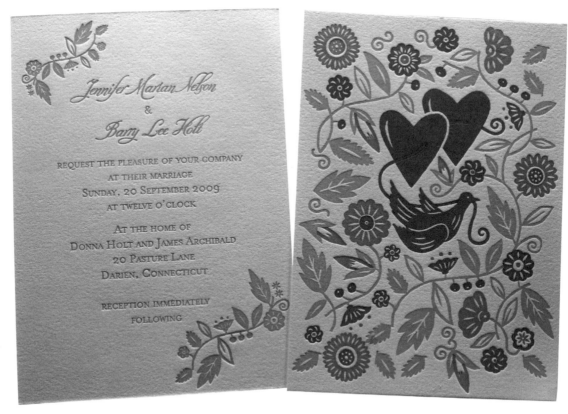

Jennifer Marian Nelson
&
Barry Lee Holt

REQUEST THE PLEASURE OF YOUR COMPANY
AT THEIR MARRIAGE
SUNDAY, 20 SEPTEMBER 2009
AT TWELVE O'CLOCK

AT THE HOME OF
DONNA HOLT AND JAMES ARCHIBALD
20 PASTURE LANE
DARIEN, CONNECTICUT

RECEPTION IMMEDIATELY
FOLLOWING

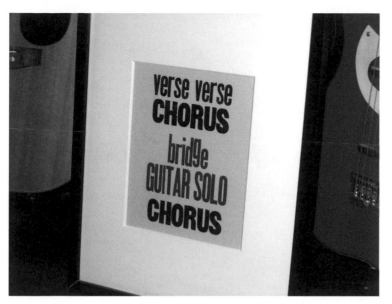

## Clementine Press

Los Angeles,
California, USA

These two prints were created by Richenda Brim of Clementine Press. The first (above left) was created as an experiment. "I play guitar, and the text was inspired by joking around with my guitar teacher during a lesson," she explains. It was printed on a Showcard Sign press using Van Son rubber-based inks. The second print (below left) was inspired by fabric, tassels, and fringing. It was printed on Somerset Satin paper using yellow ink and vintage wood type handset in silver.

# Jane Hancock Papers

## Alpharetta, Georgia, USA

These stationery collections were designed and printed by Rajshel Juhan of Jane Hancock Papers. The collections shown right and below include journals, sketchbooks, coasters, and notecards. Both sets were designed in Illustrator, and the graphics were transferred to magnesium plates with wood backing for printing. The sets were printed on a Chandler & Price press using oil-based inks and Strathmore Wove Bristol cover stock.

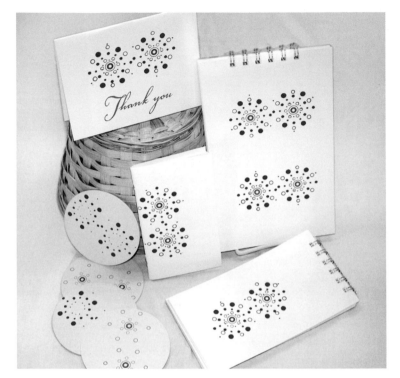

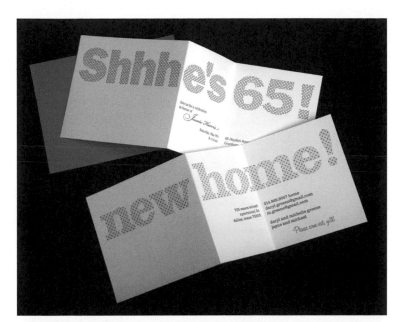

## Allie Munroe
### Miami, Florida, USA

The pieces shown here were created as part of the Allie Munroe stationery line. The birth announcement (below) and the new home card and birthday invitation (left) were designed in Illustrator, from which photopolymer plates were made ready for printing. The cards were printed on Mohawk Superfine stock.

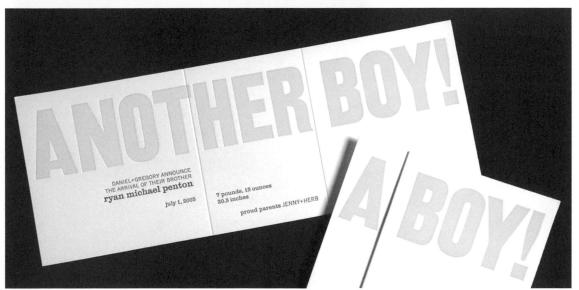

# BirdDog Press
## Lyons, Colorado, USA

The series of notecards shown on this page was inspired by the patterns and packaging schemes found on feedsacks from the Great Depression era. The designs were sketched by hand before being converted into vectors. The notecards were printed with soy-based inks on 100 percent cotton paper stock using a Chandler & Price press with a Boxcar Base and photopolymer plates.

The cards shown far right showcase the BirdDog Press collection of mismatched wood type. "I started collecting wood type and am now always finding new ways to use it," explains owner Allison Bozeman. "We hoard and covet our vintage wood type collection and use it in conjunction with our photopolymer setup whenever we can."

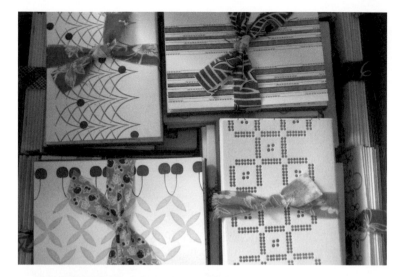

# Skin Designstudio
## Oslo, Norway

Grafill (the Norwegian organization for visual communication) asked Skin Designstudio to create a cover for its members' magazine, *SNITT*. "The theme centered around book production and art, so we felt it was appropriate to do a letterpressed cover," explains designer Erik Johan Worsøe Eriksen. "We used a newly made typeface designed by Magnus Rakeng for the Jugendstilsenteret (Jugend Style Center) in Ålesund, Norway, and let the graphics reflect the shapes and movement from the Jugendstil style, but with a pop art twist."

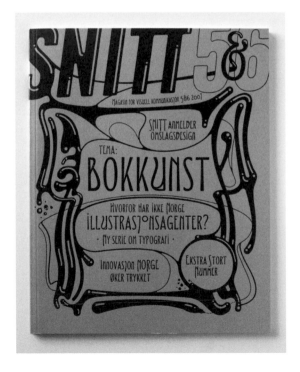

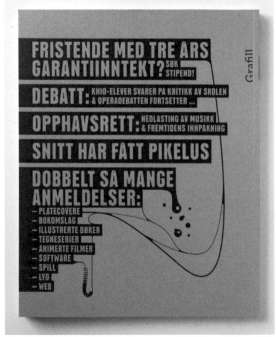

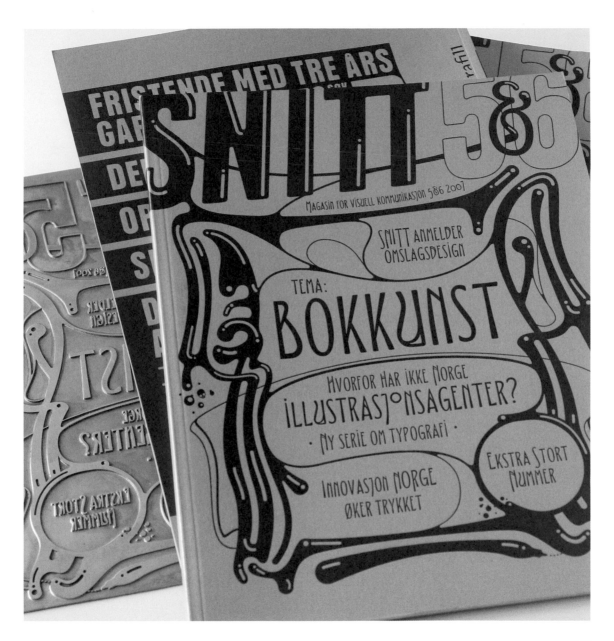

# Old School
# Stationers

Portland,
Oregon, USA

All of the pieces shown here
were hand-drawn using pen
and ink, before being made
into photopolymer plates and
printed on a Chandler & Price
press. Created by Brian Reed
of Old School Stationers, they
are inspired by events and
experiences from his youth.

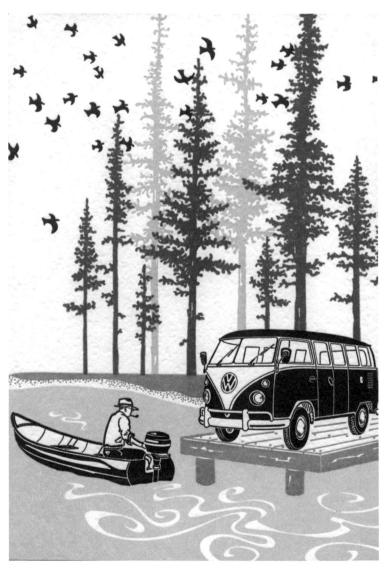

# Yee-Haw Industries

Knoxville,
Tennessee, USA

The Storetry print (right) was created by Kevin Bradley as part of a series featuring poetry developed from overheard conversations, television shows, and soap operas. It was created using handset antique wood type and was printed on a Vandercook 219 Power Proving press using oil-based inks and recycled white card stock. The music poster, shown far right, was also designed by Bradley and features antique wood and lead type as well as carved blocks. It was run through the press 12 times to achieve the desired effect.

STORETRY
NO. 046
★
°VOLUME ONE°

A NEW WRINKLE

YOUR BROTHER IS A REAL KNUCKLE-HEAD. GUYS SAY A LOT OF THINGS IN PRISON. "GOOD-BYE WEEDS, HELLO BEAUTIFUL LAWN." YOU WOULD LOOK A LOT BUSIER, IF YOU DIDN'T HAVE THAT CUP OF COFFEE IN YOUR HAND. IT'S JUST 1 BIG DIGESTIVE TRACT. I USED TO SHOOT GOPHERS. LET'S LOOK INTO THE FUTURE. WE COULD ALL BE DEAD IN 20 MINUTES. YOU DEAL IN HOT AIR, I DEAL IN CASH. YOU'RE NOT EVEN A COLLEGE GRADUATE. SMART WOMEN FIND BALD MEN SEXY. I'LL NEVER EAT LUNCH IN THIS TOWN AGAIN. EVERY BODY LOVES A WINNER. I'VE GOT SHOES OLDER THAN YOU. WHAT HAPPENED WHILE I WAS IN THE BATHROOM? YOUR LANDLADY TOLD ME WHERE TO FIND YOU.

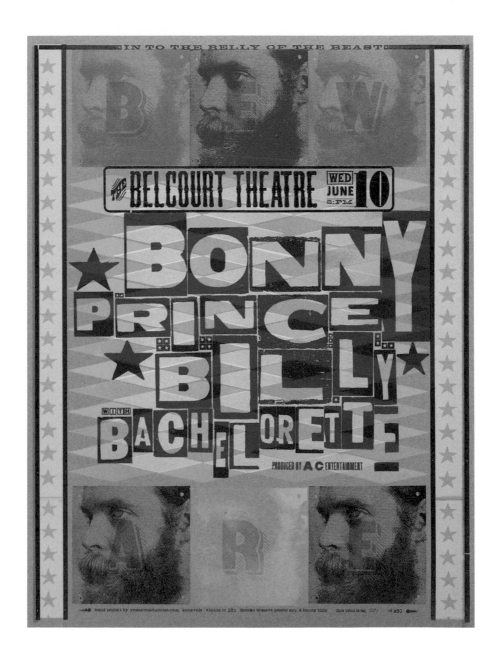

# Satsuma Press
## Corvallis, Oregon, USA

Lynn Russell of Satsuma Press
created the wedding suite shown
here. The artwork was put together
in Illustrator and was then
transferred to photopolymer
plates. The suite was printed on
a combination of Somerset and
Crane's Lettra paper stock using
a Vandercook press.

# Dawn Hylon Lucas (hyC creative)

New York, New York, USA

The animals on the cards shown here were originally drawn in Illustrator and then made into photopolymer plates by Boxcar Press. Metal type was used for the text, and the cards were printed using an Excelsior press with water-soluble etching inks.

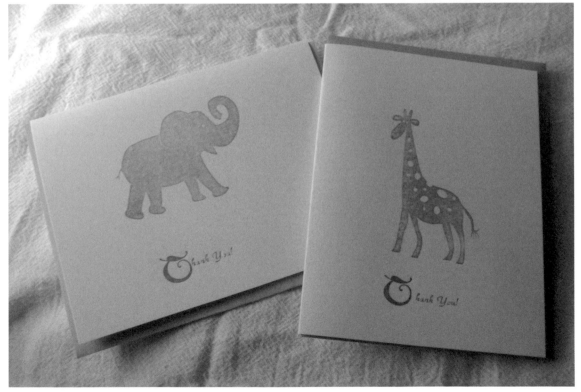

# Simplesong
## Manassas Park, Virginia, USA

The notepads shown here are from the Simplesong Old School Library range. "We love classic, simple design that reflects an old schoolhouse charm," explains Simplesong owner Suann Song. The notepads come in sets of 12, and the letterpressed sheets are bound together with a metal clip. They were printed on Crane's Lettra paper stock using a Golding No. 11 Pearl press.

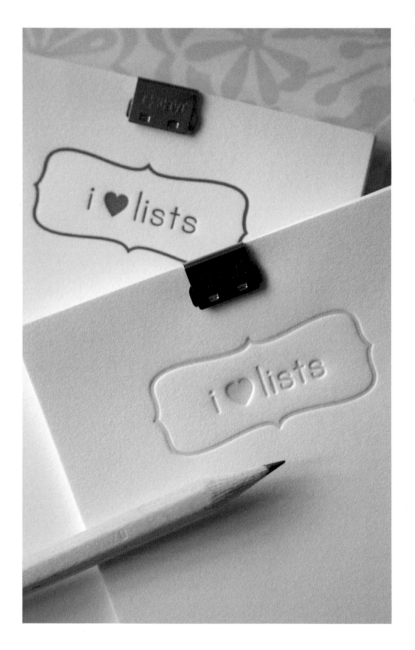

# Sergi Diaz

London, UK

These posters were created by Sergi Diaz during a letterpress workshop held at the London College of Communication. The posters are titled *Klang*, named after the type it features. They were printed using a Western press, which was built under the Vandercook license.

Some**where** over the rainbow.
**Way up high**
**There's a** land that i **heard of**
Once in a lul-a-by.
Some**where** over the rainbow.
**Skies are blue**
**And the dr**eams that you **dare to dream**
Really **do come** true.
Some*day* **I'll wish** upon a star
**And wake up** where the **clouds are** behind me.
**Where** trouble **melt like** lemon **drops**
Away above the chimney tops.
**That's** where **you'll find me**
Some**where** over the rainbow.
**bluebirds fly.**
**Birds** fly over the rainbow
Why, then, oh why **can't** I?
**If** happy little **Bluebirds fly**
Beyond the rainbow **why,oh why can't** ?!

# Blackbird Letterpress
## Los Angeles, California, USA

Kathryn Hunter of Blackbird Letterpress hand-carved the Ferris wheel image featured on the cards below from a linoleum block, and the birds were hand-drawn, scanned into Illustrator, and made into a letterpress die for printing. The blackbird image on the card shown top right was cut out of black Stonehenge paper before being scanned, resized, and also made into a letterpress die for printing.

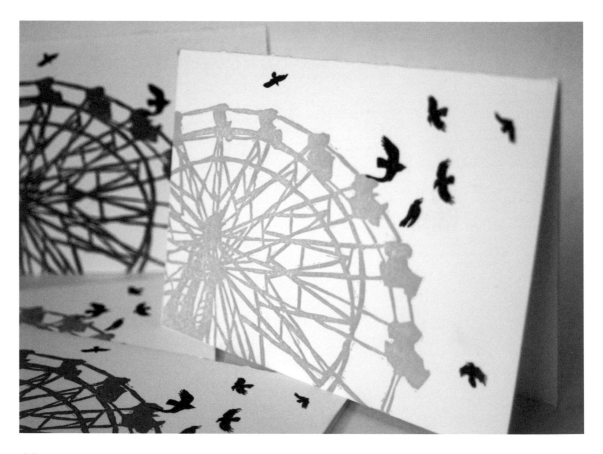

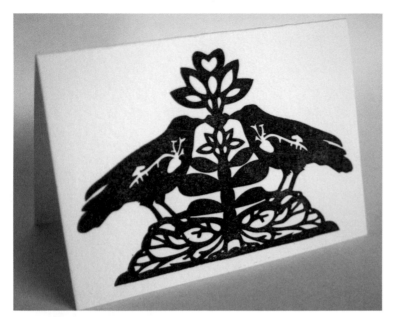

Hunter also created the imagery for the decorations shown below by hand-carving a linoleum block. The images were then printed onto circular sheets of stock and each circle was strung onto acetate ribbon. All pieces were printed on a Chandler & Price press using rubber-based inks and Crane's Lettra Pearl White cotton stock.

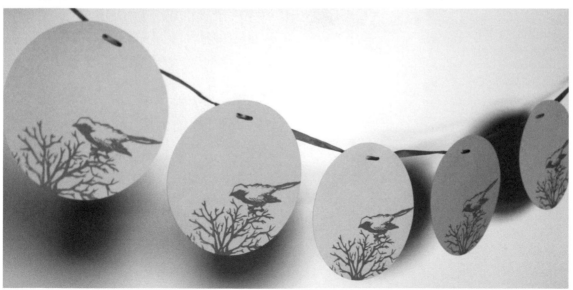

## Scott King / Horwinski Printing

London, UK / Oakland, California, USA

The posters shown here were created as part of a set by designer Scott King and printed by Horwinski Printing. "The idea was to critique the limits that most Western protest movements are prepared to go to in order to achieve their goals," explains King. "I handed over the words to James at Horwinski Printing and said, 'Please do what you want, just make it look hippie.' It was important to me that he is based near San Francisco, the seat of 1960s American counterculture." The posters feature wooden type printed over a rainbow-colored background.

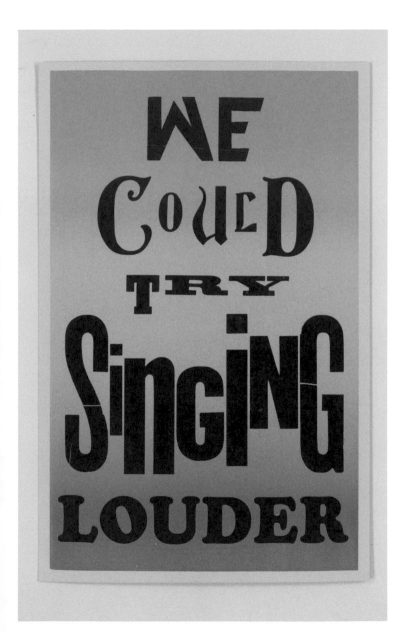

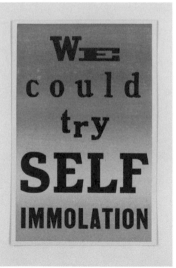

# Studio on Fire

## Minneapolis, Minnesota, USA

The calendar (below) was designed and created by Studio on Fire (see also pages 136–137). It comes with an easel for it to sit on and features work from a number of different illustrators/designers, including Clarimus, Brian Gunderson, Rinzen, and Justin Blyth. Each illustrator created imagery for a different month, and the calendar was printed in a limited edition in four colors on 100 percent cotton paper stock.

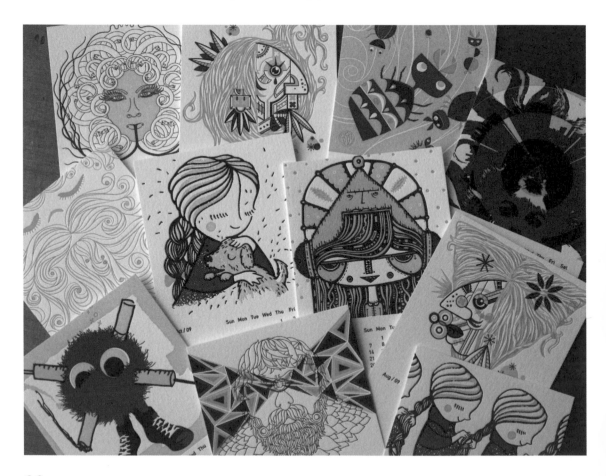

The brief for this Erik Brandt CD package (top right and below) was to create a visually intriguing design that mirrored concepts presented in the music, which was inspired by a visit to Hungary. "We designed the album packaging around the illustration and were inspired by both the tone of the album and the physicality and culture of Hungary," explains designer Erik Hamlin of Studio on Fire. The illustration was created by Andrew DeVore and made into a woodblock carving before being printed.

The brochure (below right) was created for the 2008 AIGA Minnesota Design Camp and was printed on a Heidelberg Windmill press with Crane's Lettra Pearl White cotton stock and Ahlstrom Blotter paper.

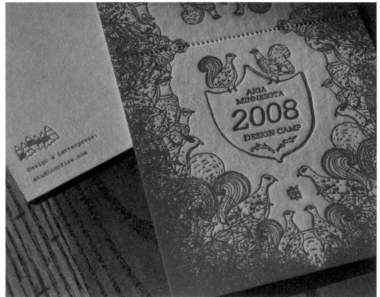

# Bittersugar
## Portland, Oregon, USA

Nik Bresnick of Bittersugar created the educational phonetic alphabet cards shown right and below after being inspired by his sister, a kindergarten teacher. "She complained to me about how ugly the cards she used were, so I decided to create some new ones," he explains. Bresnick hand-drew the images for the cards and then scanned them to create digital files that were engraved onto photopolymer plates.

H is for horse.

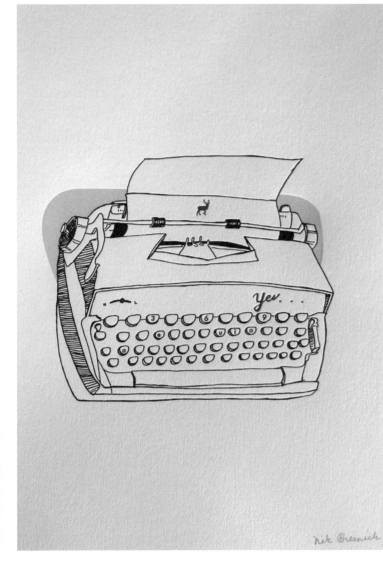

The typewriter print shown left was created in the same way, and old cycling books inspired the card shown below. All of the pieces were printed on a Chandler & Price press using oil-based inks and Crane's Lettra Pearl White cotton stock.

# Full Circle Press

Nevada City,
California, USA

This holiday greeting card was
designed by Kyle Blue and printed
by Judith Berliner of Full Circle
Press for *dwell* magazine. Snowflake
shapes were printed blind, and
the text was printed with Pantone®
inks. The cards were printed using
a Heidelberg Windmill press.

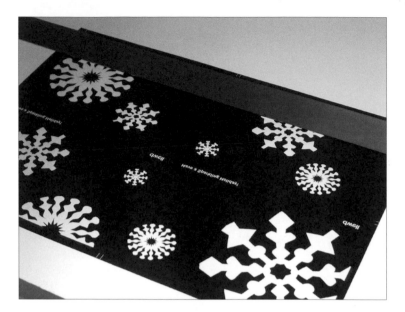

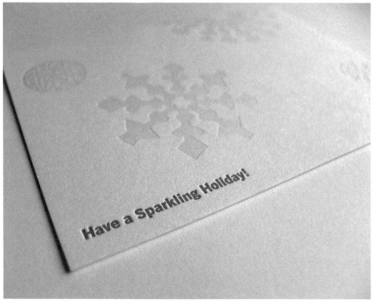

# Dolce Press

New York, New York, USA

The You're Out of This World card (below top, left and right) was the first in Dolce Press's stationery line. "Each card in this line has a whimsical graphic paired with a funny saying," explains owner Alexandra Daley. "Letterpress is really all about the interaction of design and paper, which is why we chose to focus on simple images." The cards were printed using wood-mounted magnesium plates in two passes—the silver image first followed by the blue text. The two business cards (below bottom, left and right) were custom designs, printed in black ink on 100 percent cotton card.

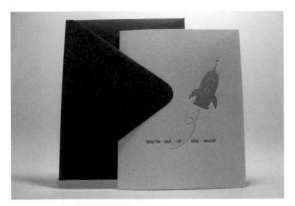

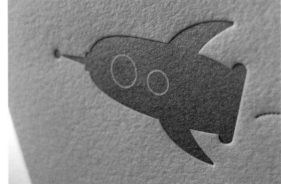

# Poppy
# Letterpress
## Canberra, Australia

The pieces shown here were designed and printed by Louise Redman of Poppy Letterpress. The engagement invitation (far right) was printed on Spicers Paper A.P. Drink Coaster Board, which was able to create a deep letterpress impression. It was printed using a Collie's Paragon 10 x 15 platen press with custom-mixed peach and red inks. The inspiration for the wedding invitation (right) was the peaceful rural setting the wedding was taking place in. The cards were printed in charcoal ink and names were later added by a calligrapher in bright colors.

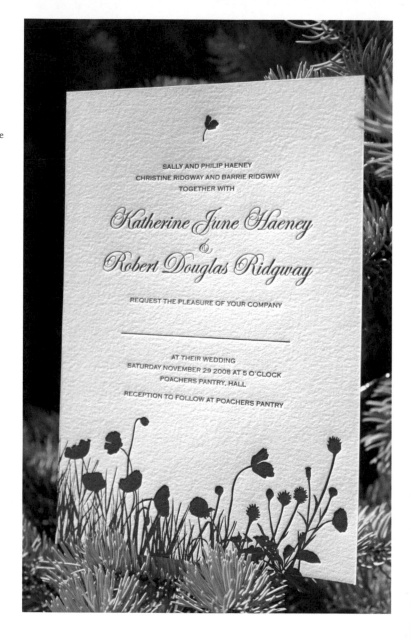

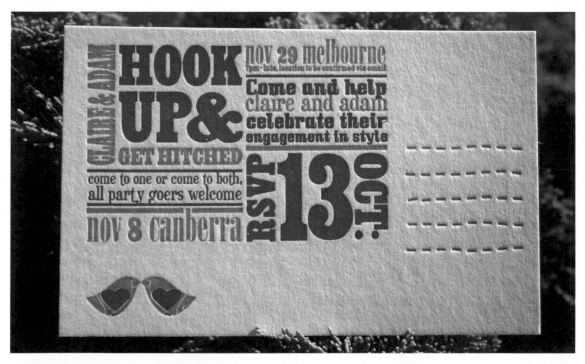

CLAIRE & ADAM

# HOOK UP & GET HITCHED

come to one or come to both,
all party goers welcome

nov 8 canberra

nov 29 melbourne
7pm - late, location to be confirmed via email

Come and help
claire and adam
celebrate their
engagement in style

RSVP 13 OCT.

# Function Matters
## Ghent, Belgium

Shown here are two posters printed by Stéphane de Schrevel of Function Matters design studio. The poster shown below was created for MIAT (Museum voor Industriële Archeologie en Textiel) in Ghent, Belgium, and the poster shown right was a self-initiated project created to showcase three different wood type fonts from the MIAT collection.

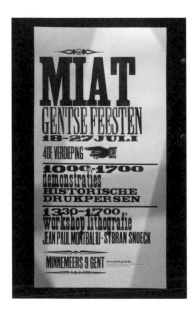

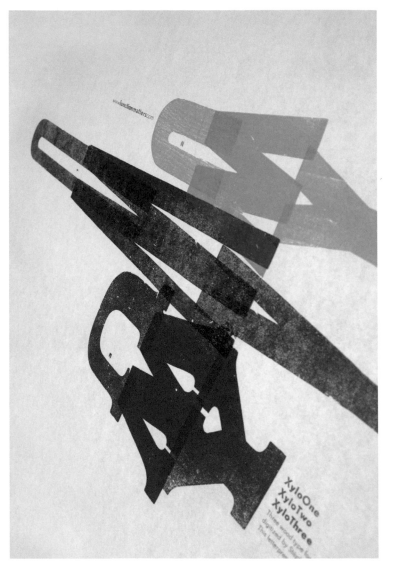

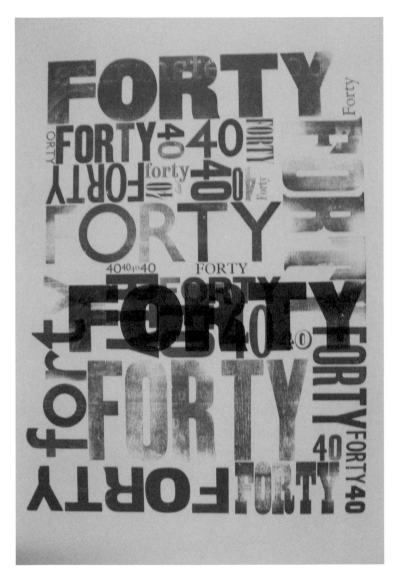

## Hand & Eye Letterpress
London, UK

Shown here is the work of London-based Hand & Eye Letterpress. The print shown left was inspired by minimalist type, and the poster shown below was inspired by jazz musician Count Basie. The posters were printed on a FAG Control press using hand-mixed inks.

# Twig & Fig
## Berkeley, California, USA

The wedding suites shown here were printed on an 8 x 10 Chandler & Price press. The first (right) was inspired by the wedding's farm location, and the second (middle) comprises many different typefaces. The postcards (far right) were printed on a Heidelberg Windmill press using matte foil on walnut wood veneer backed with paper. "We were experimenting with foil on unusual paper stocks and discovered the combination of wood and matte foil was amazing, so developed a whole line around it," explains Twig & Fig co-owner Suzie McKig.

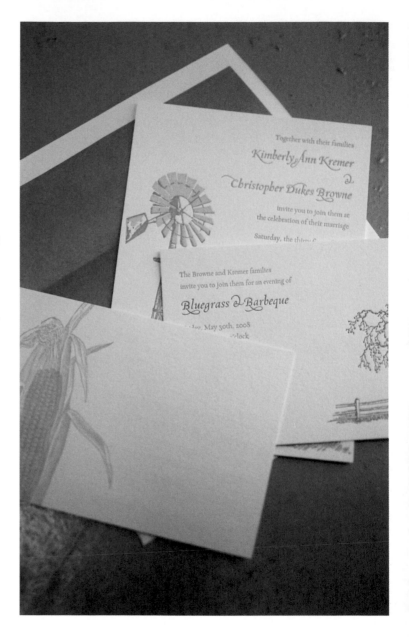

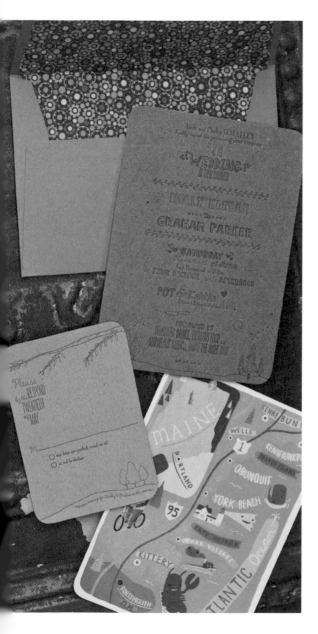

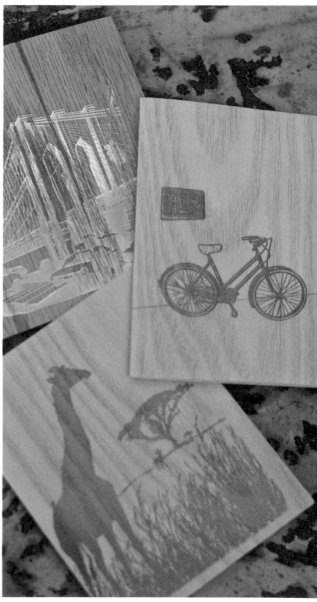

# Linda & Harriett

New York, New York, USA

Shown here are two calendars designed by Linda & Harriett owner
Liz Coulson Libré. Both calendars were printed on a Heidelberg press
using soy-based inks and 30 percent post-consumer and 100 percent
carbon neutral paper. The 2010 calendar (below) has a double use, with
the reverse side of each month designed as a postcard, allowing users to
cut and reuse them.

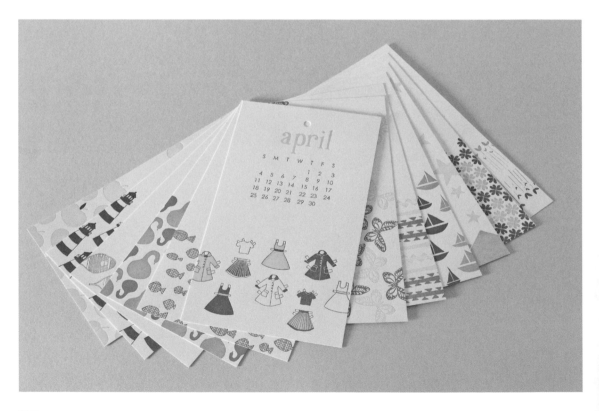

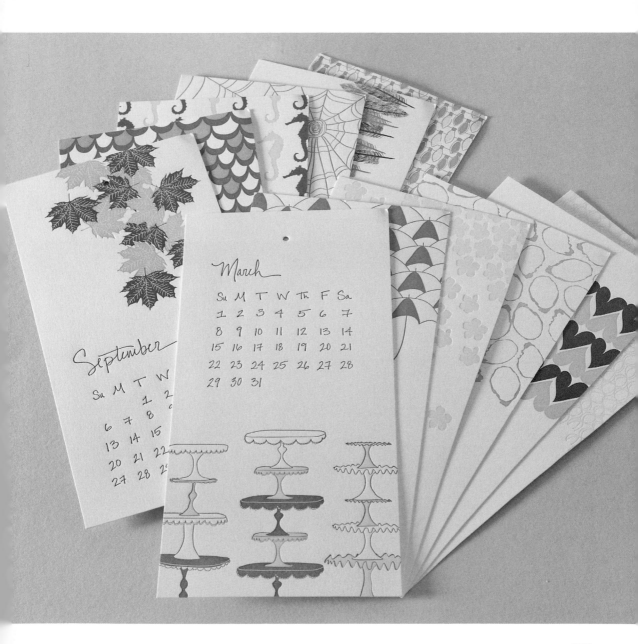

# Ella Studio

## Pittsburgh, Pennsylvania, USA

These cards were created by Lisa Delu Vavrick of Ella Studio for her Candid Card and Holiday Obligation collections. "My inspiration for the Candid cards was to design a line that says what the sender is really thinking," she explains. With the Holiday Obligation collection the sentiment was similar. "A beautifully letterpressed card that pairs classic typography, sentiment, and holiday imagery with an unexpected message on the inside is fun and allows the receiver to share the joke" (see below). Both card ranges were printed on a Vandercook SP15 press.

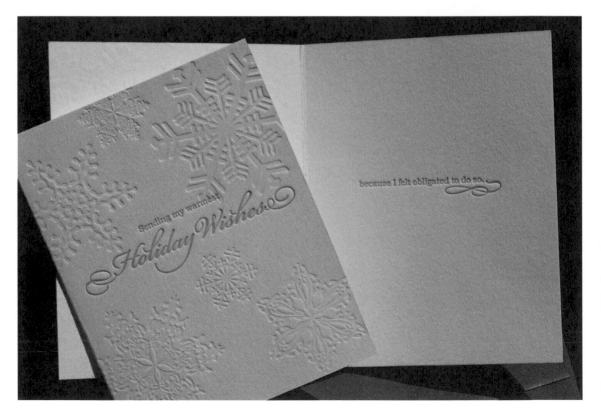

# Studio Olivine
## Portland, Oregon, USA

Portland-based Studio Olivine created these coasters for the studio's product line, each of which comes packaged in a box of seven. Both sets were created using hand-drawn illustrations that were scanned, made into a negative, and then turned into a magnesium plate. They were printed using soy-based inks and recycled pulpboard.

# Sweetbeets

## Hamilton,
## Ontario, Canada

The cards shown here were inspired by the magic of childhood and life's simple pleasures. Lisa Zuraw of Sweetbeets created the artwork in Illustrator and then made them into photopolymer plates for printing. The red "2" card (bottom right) is one of the most popular items in the Sweetbeets collection. "It was originally intended to be used as a second birthday card or as a congratulatory card on the birth of twins, however people have also bought it as a second wedding anniversary card or simply as a wedding card," explains Zuraw. All of the cards were printed on a Heidelberg Windmill press using rubber-ased inks and 100 percent recycled paper.

# Rohner Letterpress

## Chicago, Illinois, USA

Shown here are a number of projects designed by various designers
and printed by Rohner Letterpress (see also pages 28 and 182–183).
The greeting cards shown on this page were designed by Amy Bannecker
of Embellished Ink. "I love combining woodcut imagery with fresh colors
and wanted the cards to be sophisticated and simple," explains Bannecker.
The cards were printed on a Heidelberg SBG Cylinder press using Beckett
Concept Glacier Vellum stock from Mohawk Fine Papers.

**84**

The sketchbook shown on this page was designed and illustrated by Amy Allison of SODA by Amy, and features original hand-drawn illustrations inspired by childhood. The journal covers were printed on a small-format Heidelberg Windmill press to accommodate the thickness of the cover board. Divider pages were combined and printed on six color stocks using a Heidelberg SBG Cylinder press, and the books were then bound together.

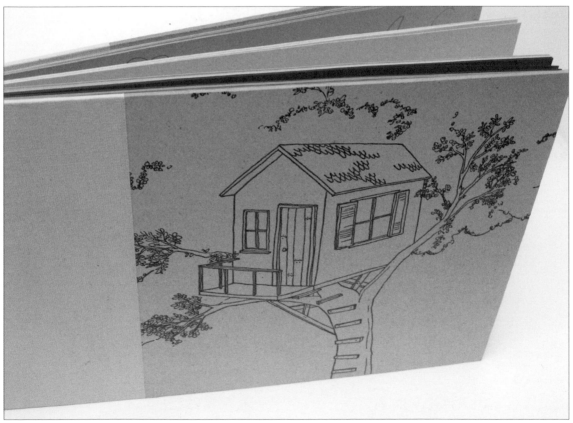

# Dee & Lala

Los Angeles, California, USA

This farmland collection of greeting cards was designed by Christen Cutrona of Designeka and printed by Dee & Lala, a solar-powered press in Los Angeles. Taking inspiration from a nearby farm, Cutrona sketched each illustration from an idea, memory, or observation. The final artworks were created in Illustrator, which were then converted to plates before being printed on a Vandercook Universal I press using Van Son rubber-based inks and Crane's Lettra Fluorescent White cotton stock.

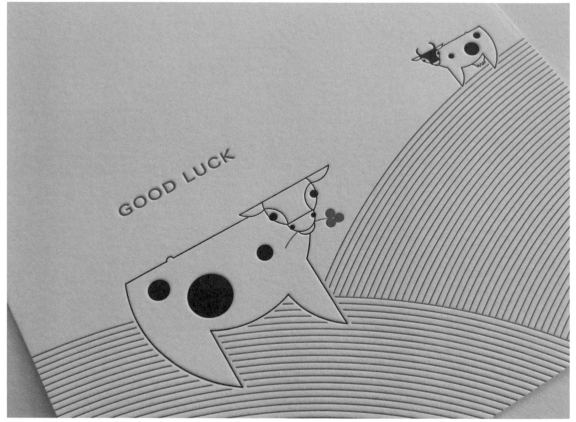

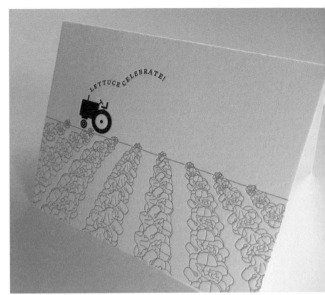

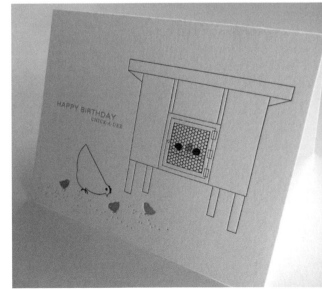

# Ruby Victoria

## Hobart, Tasmania, Australia

Ruby Victoria owner Narelle Badalassi created the cards and tags shown here. The Christmas tags (far right) were designed as an alternative to the usual high-gloss tags found in commercial stores. "I started making small gift tags to accompany my cards and I found that people really responded to their lovely soft texture." The tags were printed on 250gsm 100 percent Canson Cotton Rag paper. The recipe cards (top right) were inspired by an increased popularity in home cooking, and feature a mix of handset lead type and hand-carved lino block images. The cupcake invitations (below right) were first printed in pink on an Adana press and were then run through the press again to add the type in a different color.

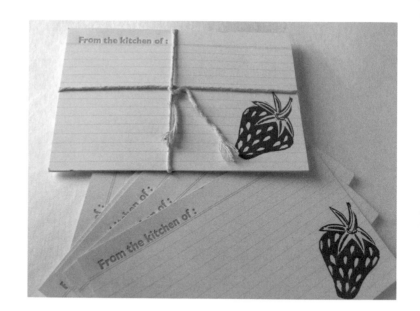

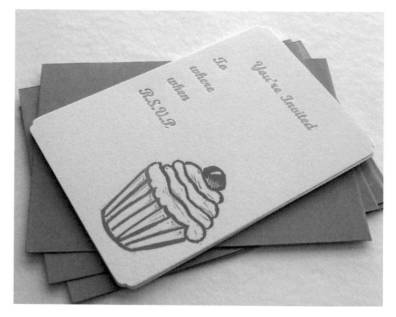

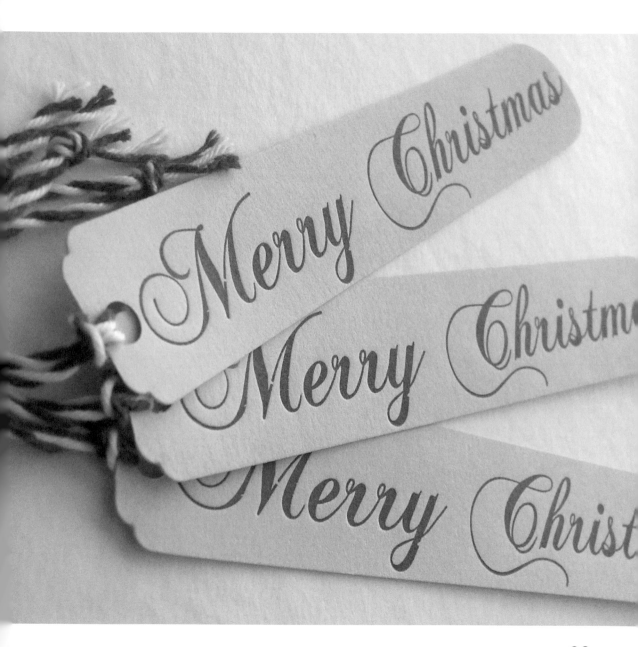

# Ross MacDonald
## Newtown, Connecticut, USA

Ross MacDonald created these book covers for Tor Books. The brief for the cover shown below right was to create a rustic, nineteenth-century broadside look. MacDonald created a linocut illustration (shown right) using old, hard linoleum and cut it with wood-engraving tools. He used a split-fountain printing technique with fluorescent inks. The cover below was created by sticking several layers of old letterpress prints together. It was printed in a similar way using wood and metal type.

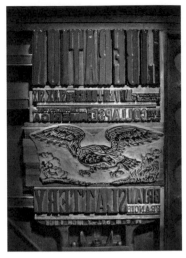

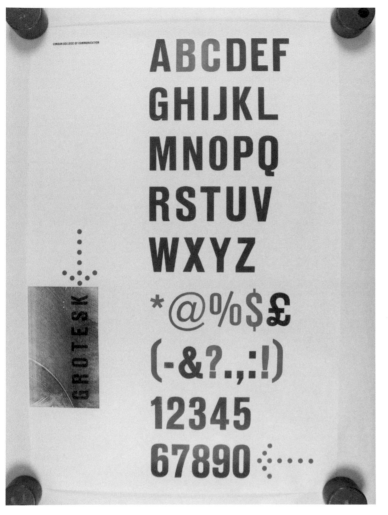

## Eric Eng Design
London, UK

London-based designer Eric Eng created this poster, titled *Grotesk*, as part of the Type Specimen Project at the London College of Communication. "It was an academic exploration of the proportions of wood type, digital vs. wood type, and experimentation with printing techniques, mixing inks, printing in large formats, and with two-color processes," he explains. The poster is now part of the studio's resources.

# Goosefish Press

## Boston, Massachusetts, USA

This wedding invitation and stationery set was designed and printed
by Rob Charlton at Goosefish Press. The brief was to create something
floral and modern, yet classic. The set was printed from photoengraved
magnesium dies mounted on wood using a Chandler & Price press with
custom-mixed inks and Crane's Lettra stock.

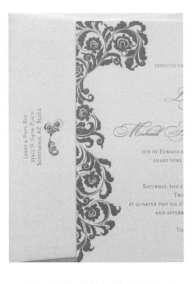

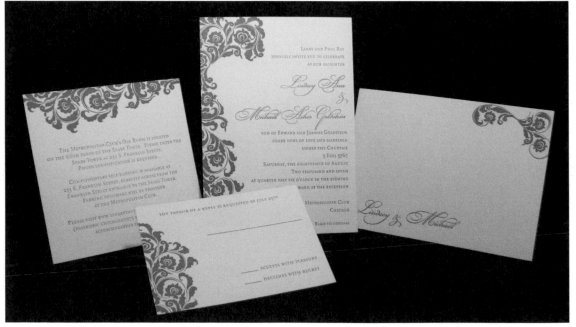

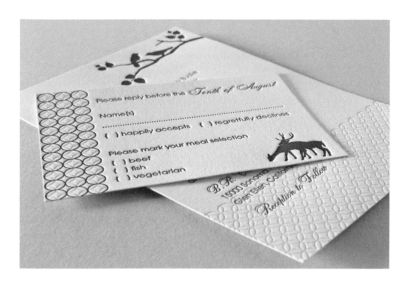

# Flora and Fauna Press

Los Angeles,
California, USA

This wedding suite was designed
by Christine Brandt of Flora and
Fauna Press. It features hand-
drawn illustrations that were
scanned and then made into
photopolymer plates before being
printed using a Vandercook No. 4
proof press with Van Son rubber-
based inks and Crane's Lettra
stock. The suite was inspired
by whimsical nature, animals,
and contemporary patterns.

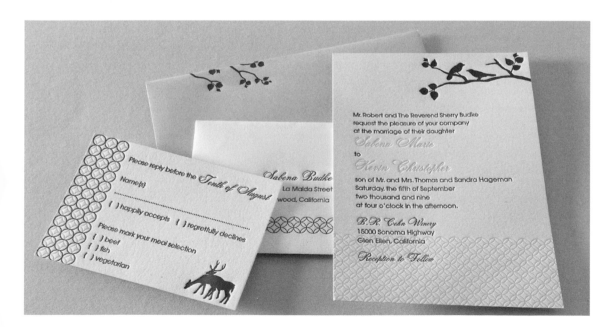

# Truly Smitten

## Iowa City, Iowa, USA

Sarah Kim of Truly Smitten
designed the wedding set shown
right with a delicate, Victorian
style in mind. It features imagery
found in clip art books and
decorative type and was printed
on a hand-fed platen press using
Crane's Lettra cotton stock.
The wedding set (far right, bottom)
was designed in Illustrator by Kim
for her own wedding. "Gingko
leaves have a significant meaning
to my family—it is my father's
favorite tree, so the idea was
to combine this with my love
of yellow," she explains. Both
invites were printed by Thomas-
Printers in Pennsylvania.

The notecards shown above right
were designed to be clean and
classic, with a hint of baroque
elegance. The type was printed
with gold foil and the motif was
debossed without ink on Crane's
Lettra cotton stock by AccuColor
Plus in Chicago.

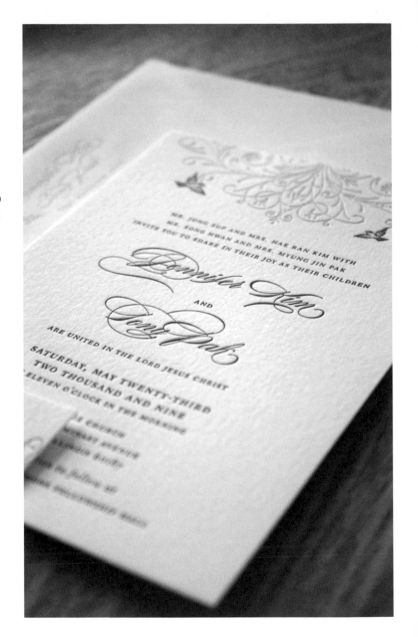

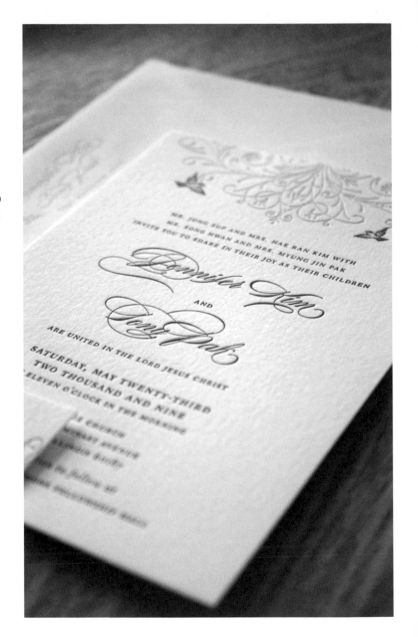

MR. JUNG SUP AND MRS. HAE RAN KIM WITH
MR. SONG HWAN AND MRS. MYUNG JIN PAK
INVITE YOU TO SHARE IN THEIR JOY AS THEIR CHILDREN

*Jennifer Kim*

AND

*Sang Pak*

ARE UNITED IN THE LORD JESUS CHRIST
SATURDAY, MAY TWENTY-THIRD
TWO THOUSAND AND NINE
ELEVEN O'CLOCK IN THE MORNING

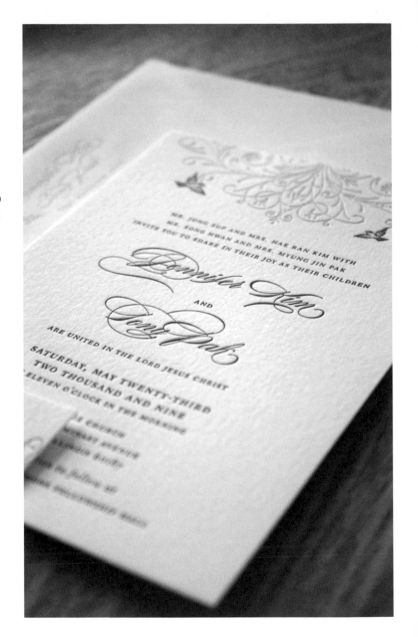

**94**

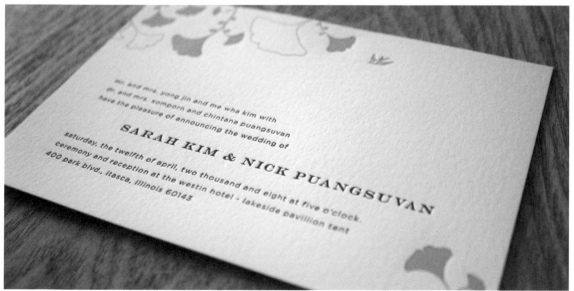

mr. and mrs. yong jin and me wha kim with
dr. and mrs. somporn and chintana puangsuvan
have the pleasure of announcing the wedding of

**SARAH KIM & NICK PUANGSUVAN**

saturday, the twelfth of april, two thousand and eight at five o'clock.
ceremony and reception at the westin hotel - lakeside pavillion tent
400 park blvd, itasca, illinois 60143

# Gilah Press + Design

Baltimore, Maryland, USA

These greeting cards were designed by Kat Feuerstein for Gilah Press +
Design's Super Loud collection. The idea was to create a line of cards that
was bold and graphically pleasing, with a focus on typography and pattern.
They were produced on a 12 x 18 Chandler & Price press using a metal
base and photopolymer plates. The perfect balance of impression, roller
height, and ink quantity was needed in order to get solid coverage on the
type, while maintaining detail in the small patterns.

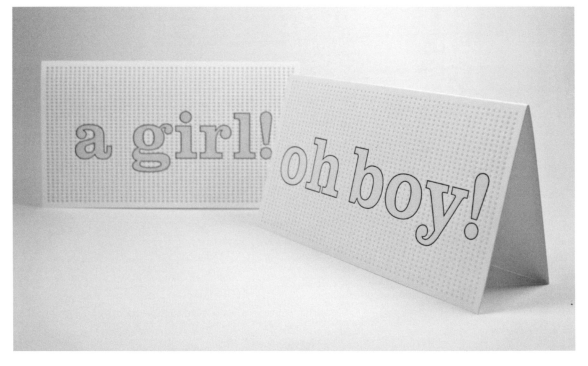

# Gilah Press + Design /
# Ice Cream Social

Baltimore, Maryland / New York, New York, USA

This wedding suite was designed by Ice Cream Social (see also pages 98–99) and printed by Gilah Press. After talking with the couple, the designers decided to represent the fruits of their home states—the apple (New York) and the peach (Georgia). The main logo was inspired by vintage fruit wrappers, and the cloth pouches also nod to old jelly jar lids covered in fabric. "We think these beautiful invitations set the mood perfectly for an upstate New York summer wedding, while also bringing in some Southern charm," explains Jennifer Perman of Ice Cream Social. The invites were printed on a 12 x 18 Chandler & Price press using photopolymer plates and a metal base.

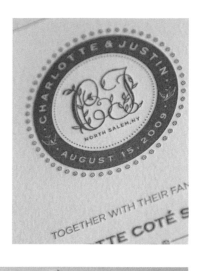

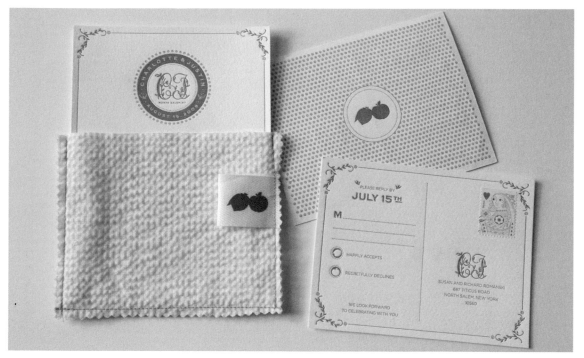

# Ice Cream Social
## New York, New York, USA

Jennifer Perman and Mary Boyko at Ice Cream Social printed the pieces shown here. They created the artwork and type featured on the card shown right, and printed it using a Chandler & Price press with photopolymer plates on a metal base. The wedding suite shown below was created for a couple who live in London, got engaged in Paris, and were getting married in New York. The Ferris wheel was an original illustration, and the other imagery came from vintage-themed clip art.

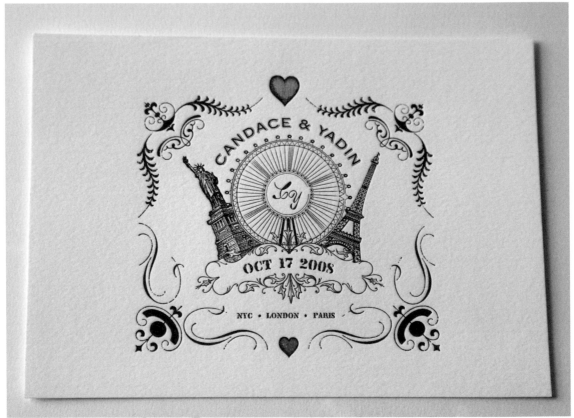

The wedding set shown left was also created using found vintage imagery and was printed in green and turquoise inks, reflecting the wedding's outdoor vintage-style setting. The wedding suite shown below was designed for a couple who love dogs and mixes vintage details and patterns. The suite was printed on a Chandler & Price press using Crane's Pearl White paper stock.

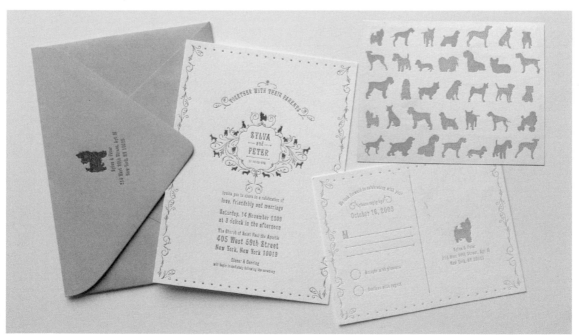

# Armina Ghazaryan

Ghent, Belgium

Designer Armina Ghazaryan created the posters shown here. The two
prints below were created using an etching press with wood type and
metal engravings assembled on a wooden block. Both were printed
on etching paper. The poster (right and far right, top) was created as
a promotional item for MIAT (Museum voor Industriële Archeologie
en Textiel) in Ghent, Belgium, for which Ghazaryan wanted to create
something modern using old materials and techniques. It was printed
using a nineteenth-century iron handpress with wooden and movable
type in a limited edition of 100 copies. The poster (far right, bottom)
was inspired by Dutch artist, typographer, and printer H. N. Werkman
and was printed in the same way.

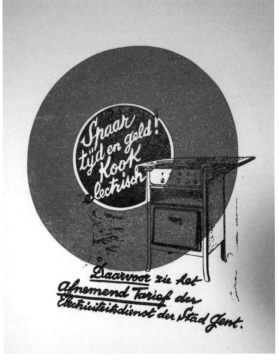

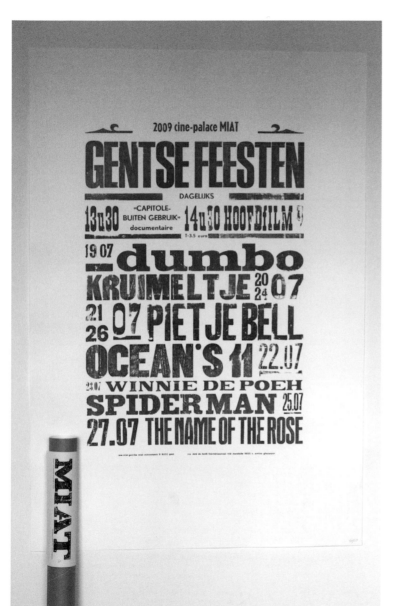

# The Paper Thieves

## Los Angeles, California, USA

The calendar shown right was designed by The Paper Thieves' owner Stephanie Meurer. It sits on a walnut wood base, and its design was inspired by bingo cards. The Hello card (below) was created using vintage wood type. It comes with a clear plastic envelope so that people can see the card's message as it goes through the mail.

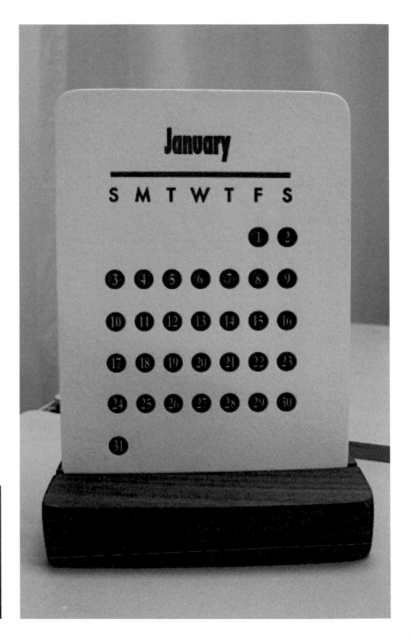

## DWRI Letterpress
Providence,
Rhode Island, USA

Inspired by hearing Michael McDonald sing "America the Beautiful" at the Democratic National Convention in 2008, Dan Wood of DWRI Letterpress created the poster (below left), which was later revised and sent as a New Year's card for his shop. He used Hearst Antique type set in wood around a Boxcar Base that held the polymer plate Obama image. The card shown top left was printed on a Vandercook press using oil-based ink on faux velvet jewelry packaging material.

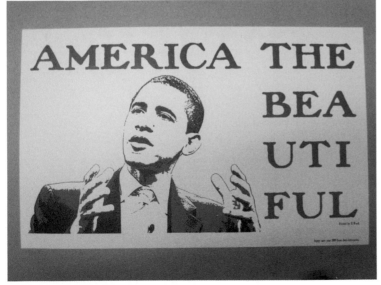

AMERICA THE
BEA
UTI
FUL

# Harrington&
# Squires
## London, UK

The limited-edition book (shown right) is a self-initiated project inspired by a poem about firewood written by Celia Congreve. The words referring to wood were printed using wooden type, while the rest of the book was printed using metal type. The pages were printed in several sections, glued together to form French folds, and then Coptic-bound in various hardwood front and back covers. Concertina-folded letter cards from the 1920s and 1930s inspired the design of the card shown far right. It features the word "Love" on the front printed using wooden type. All of the Harrington&Squires pieces were printed on an Adana 8 x 5 press.

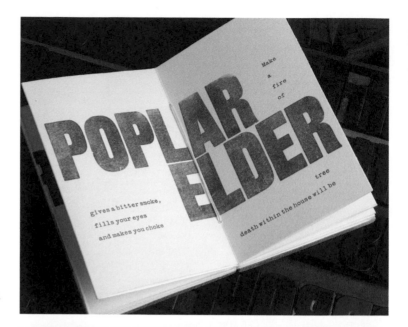

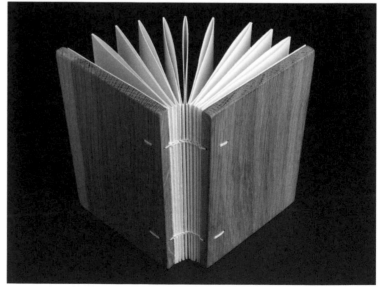

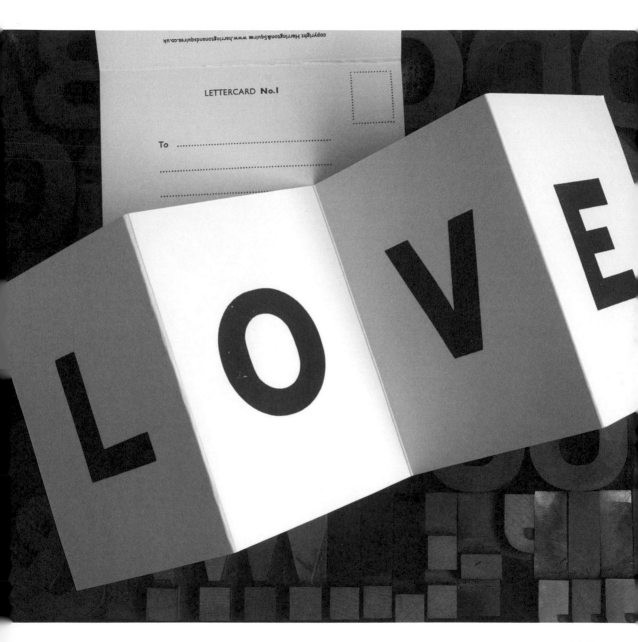

# Inky Lips Press
## Dallas, Texas, USA

This poster was printed for the third United Designs Biannual International Design Exhibition in Amman, Jordan. "The concept was to use a hand, which represented the people of Earth, and the responsibility we have for our planet," explains designer M. Casey McGarr of Inky Lips Press. The poster was printed on a Vandercook press using a split-fountain technique.

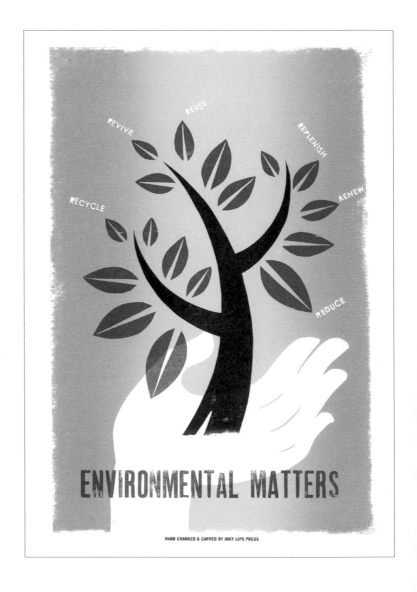

# Jackson Creek Press

Peterborough, Ontario, Canada

Shown here are three posters designed and printed by Jeffrey Macklin of Jackson Creek Press. The posters shown right and below left were created to advertise local independent music festivals. They were printed on a FAG Standard TP550 proof press using rubber-based inks, and feature a variety of different wood and lead type. The poster bottom right features a hand-carved lino block print of Cory Doctorow, a journalist and author, and is part of an ongoing series focusing on Canadian personalities. It was printed in the same way.

# Letterpress Delicacies
## Austin, Texas, USA

Thomas Hollifield of Letterpress Delicacies designed the cards shown
here in Photoshop and Illustrator, and then transferred the graphics
to steel-based photopolymer plates for printing. Each card was printed
on a Vandercook Universal I press using oil-based, hand-mixed inks.

BON VOYA

BONJOU

# Gavillet & Rust

Geneva, Switzerland

This series of invitations was created for the SAKS Gallery in Geneva. Gavillet & Rust was commissioned to design the gallery's identity, and the look was carried through to their invites. "A signature typeface was designed for their identity, which incorporates 1950s cool," explains designer David Rust. The invites were printed on a Heidelberg press using board stock and foil stamping.

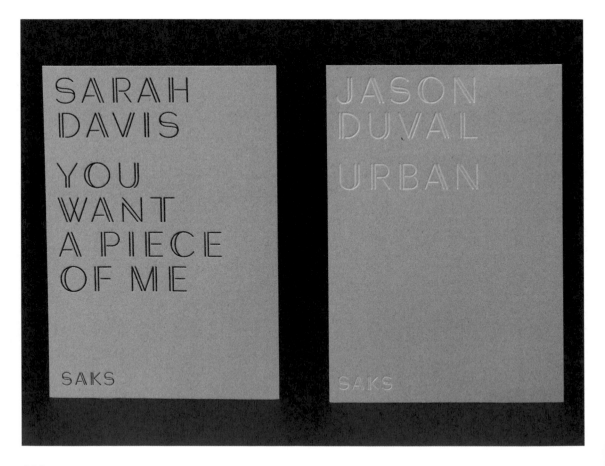

# Typoretum
## Colchester, UK

Justin Knopp at Typoretum created this concertina-folded greeting card. The card features French antique wood type, and it was printed on Somerset Velvet stock using a Gietz Art platen press.

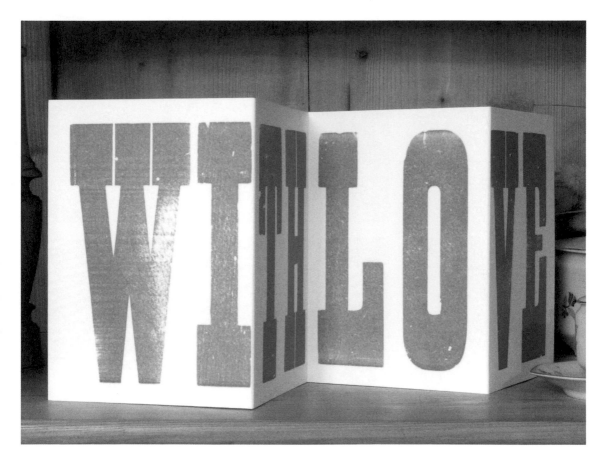

# Jens Jørgen Hansen

## Holsted, Denmark

Shown here is the work of Danish designer and printer Jens Jørgen Hansen. Each piece was printed on a hand-driven flatbed cylinder press using oil-based inks. The heart card (right and below) was designed for his mother's birthday. After printing the heart in red ink, Hansen brushed gold powder over the top to achieve the shimmery finish. The birthday card (center right) was designed for his father's seventieth birthday and was put together using lead and wood type. The idea behind the Type Specimen poster (far right and far right below) was to showcase different varieties of metal and wood type.

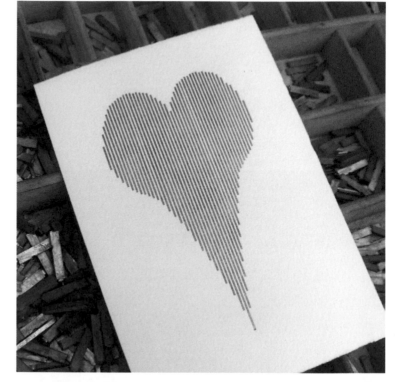

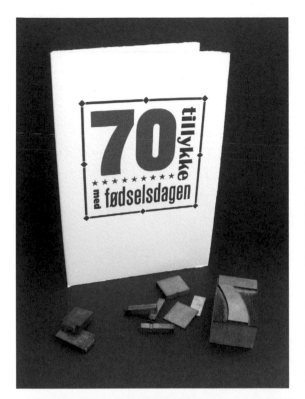

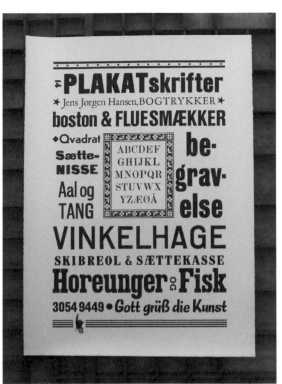

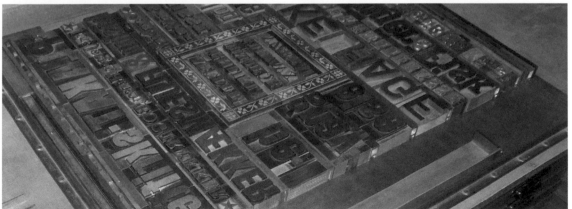

# Pancake & Franks
## San Francisco, California, USA

Stacy Pancake of Pancake & Franks designed these greeting cards. "I live in the very gastronomical city of San Francisco, where my lifestyle and design work are influenced by food culture," she explains. As a result, Pancake has created many food-related cards, including the herb series (below) and the teacup and tea bag cards (right). All of Pancake's imagery was hand-drawn and scanned. The cards were printed on a Heidelberg Windmill press using soy-based inks and 100 percent recycled stock.

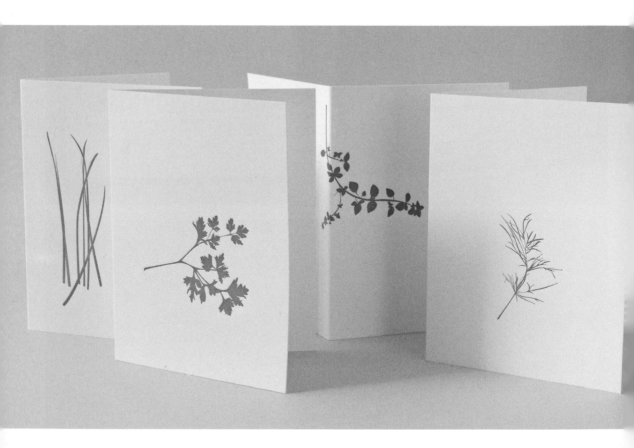

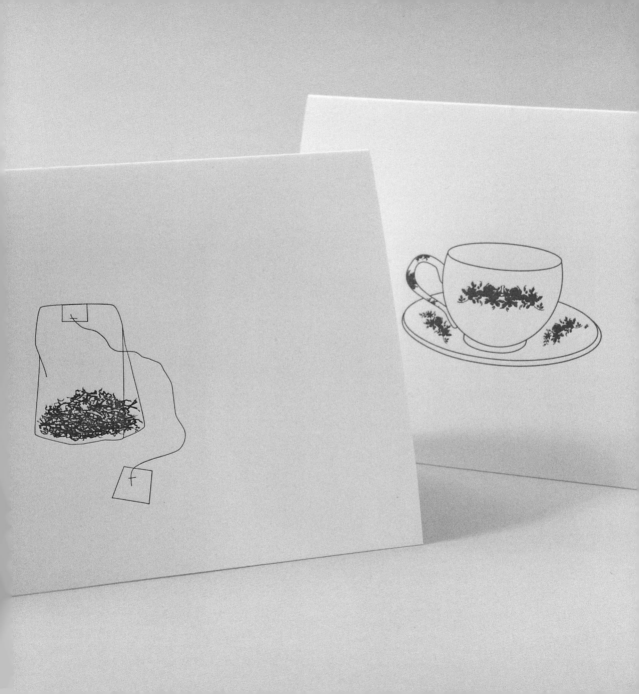

# Cranky Pressman

Salem, Ohio, USA

The coaster shown on this page is a cross-promotion between Mikey Burton of Little Jacket and Cranky Pressman, and is a way of expressing their undying love of Ohio. The typography and imagery for the coaster was created digitally and then made into a magnesium plate for printing, and the Ohio shape came from a found die-cut.

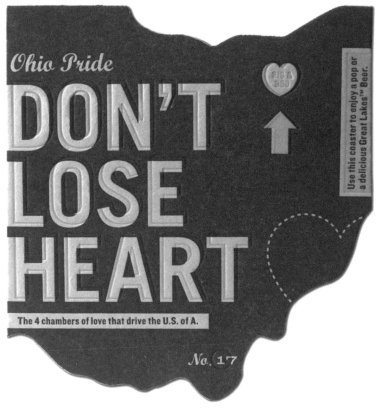

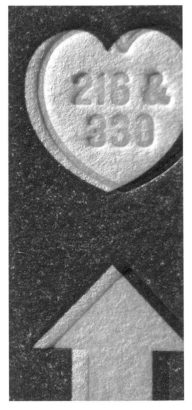

The trade card (right and below right) features original artwork
by illustrator David Flaherty, and the poster (below) was designed
by Burton for online art gallery 20x200. Each Cranky Pressman
piece was printed on a Heidelberg Windmill press using eco-friendly,
vegetable-based inks.

# Angela Liguori

Boston, Massachusetts, USA

The series of cards shown here were designed and printed by Angela Liguori. Each card combines the use of brocade alphabet ribbons with letterpress printing. Each card was printed on 100 percent cotton stock, and the ribbon letters were applied later by hand.

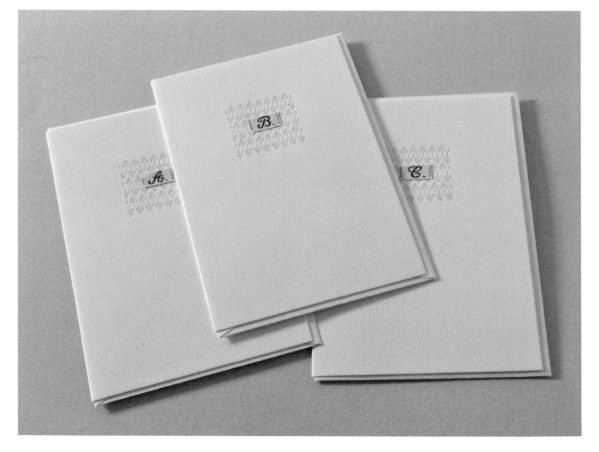

# Snow & Graham

Chicago, Illinois, USA

Shown here are two cards designed by Ebony Chafey of Snow & Graham. The Many Thanks card was printed on a Heidelberg Cylinder press using vegetable-based inks, and the Congratulations card was created in the same way using one of Chafey's original illustrations.

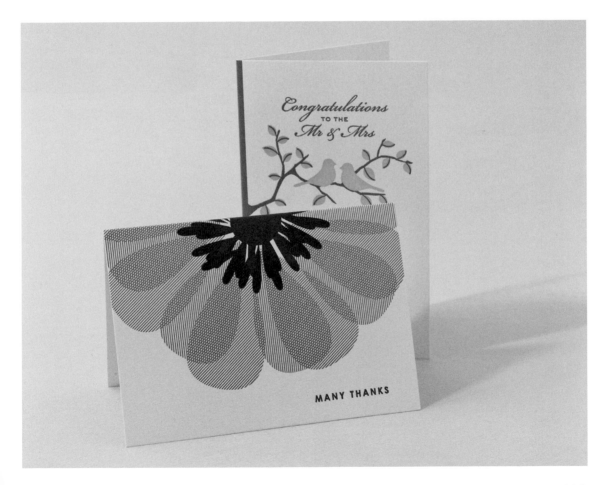

# Studio 204
## Dallas, Texas, USA

Each of the posters shown here was printed on a Vandercook Power 219 press. The poster shown right and center right was created by Virgil Scott of Studio 204 for the Lone Star Early Ford V-8 Club and its annual swap meet. The illustration was silkscreen-printed and then the type, set in both wood and metal, was printed using hand-mixed, oil-based inks. The poster shown below was created by Scott and Kim Neiman for the annual art faculty exhibition at Texas A&M University Commerce and was printed on kraft paper. The poster shown far right was created by Scott for a show based on the theme of soda pop art, put on by a group of Texas-based letterpress printers and designers under the name of Lone Star Letterpress Werks.

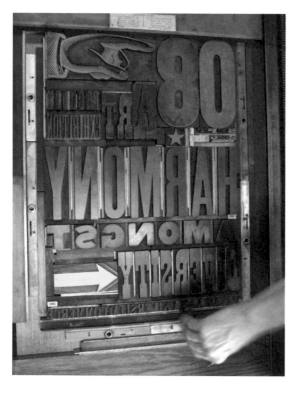

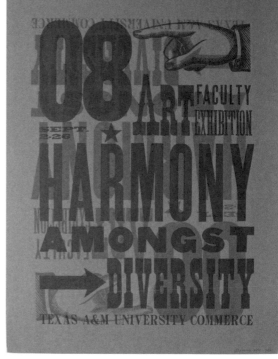

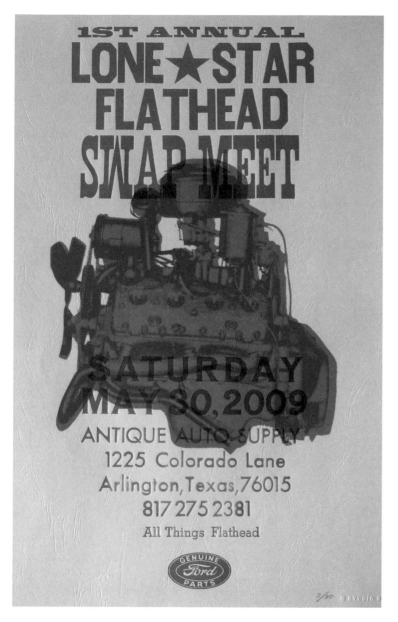

"The slogan, 'You like it. It likes you' was used on 7UP bottles and cans in the 1950s and speaks to the simplistic, direct, and honest marketing messaging of the time," explains Virgil Scott of Studio 204. The poster was printed using vintage wood type.

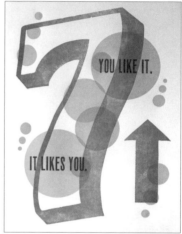

# Tiny Pine Press

## South Pasadena, California, USA

Calligrapher Laura Mendoza created the text for the vintage-themed wedding invitation shown right and far right. To create the engraving plates, the fine and delicate hand-drawn calligraphy was shot to film. The invites were then printed by Jennifer Parsons of Tiny Pine Press using a tabletop handpress and natural white museum board with soy-based inks. Antique circus posters and tickets inspired the first birthday party invitation shown below. The invites were printed on a Chandler & Price press using chartreuse and pink soy-based inks on natural white printers vellum.

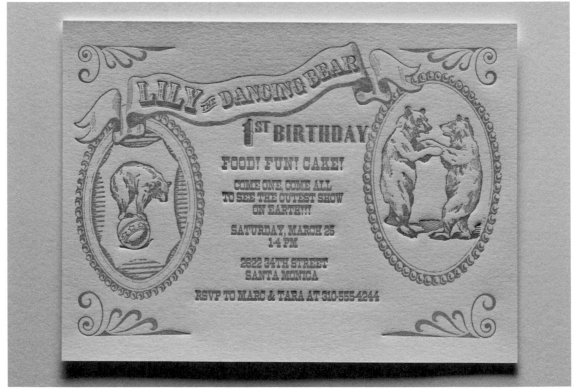

*Please save the date*

*Ashley Robbins*
*and*
*Jeffrey S. Quicksilver*

*August 25-27, 2006*

*Malibu, California*

# On Kamal
## Richmond, Virginia, USA

On Kamal owner Kamal Patel designed the cards shown here. Explaining the card shown right, she says: "The peacock has always been one of my favorite animals, and I wanted to capture their bold colors and swirling patterns simply and graphically." The artwork was originally created by hand and then printed using a 10 x 15 Chandler & Price press with 100 percent cotton paper stock. Kamal was inspired to create the card shown below following a trip to her ancestral home of India. The vibrant hue in the middle of the starburst was created by giving the card a few hits of color before the burst pattern was printed over the top.

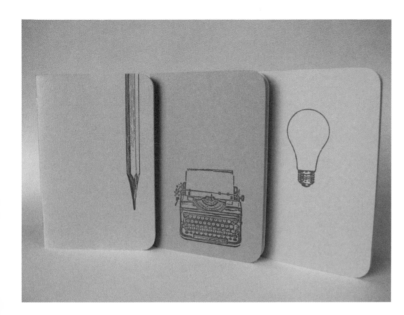

# Albertine Press
## Somerville, Massachusetts, USA

The pocket-sized journals shown left were designed by Shelley Barandes for Albertine Press's wholesale collection and were printed on a Vandercook press. The covers feature different vintage illustrations that evoke ideas about communication. The coasters shown below were created for the press's wholesale line using vintage Chinese paper-cut images. They were printed on a Chandler & Price press using rubber-based inks in a variety of bold and bright colors.

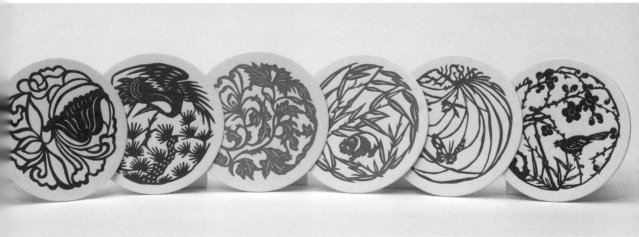

# ive-Route

## Berkeley, California, USA

The wedding suite shown on this page was designed by Olivia San Mateo of Olive-Route for a couple having their wedding at a farm in the Vermont countryside. The invites were printed using a combination of Vandercook and Chandler & Price platen presses on Crane's Lettra 100 percent cotton card stock, Bugra stock for the blue postcard, and recycled French Paper Company stock for the pocket folder.

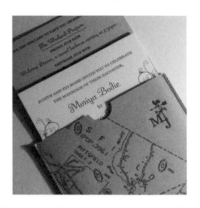

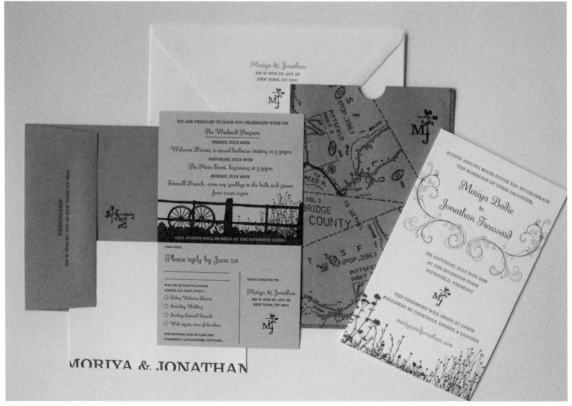

The coaster shown here was made for a good friend of San Mateo's who wanted something unique to give away to guests attending her birthday party. Old type specimen books inspired the layout, and fun, vintage ornaments accompany bold typography. They were printed on a Chandler & Price press using coaster board.

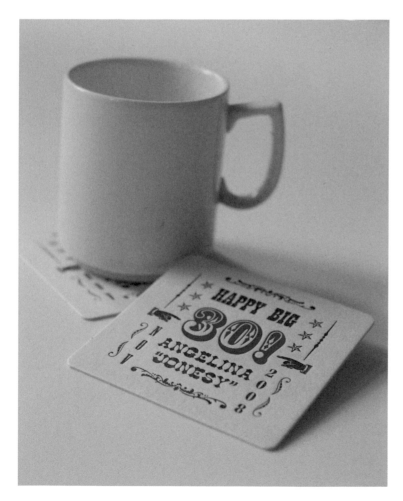

# Starshaped Press
## Chicago, Illinois, USA

This poster was created as a submission to a poster project in Chicago, and was inspired by the explosion of citywide gardening. "I wanted the poster to be made entirely out of wood and metal type that we had in the studio, while also showcasing the idea of gardens rising up in the city, much like wartime Victory Gardens," explains Jennifer Farrell of Starshaped Press. The backs of wooden type have been used to print the cityscape, which give it a blocky effect, and the vegetation was made up of borders and ornamental materials. The poster was printed on a Vandercook SP15 press with vegetable oil-based inks and French Paper Company Whip Cream cover stock.

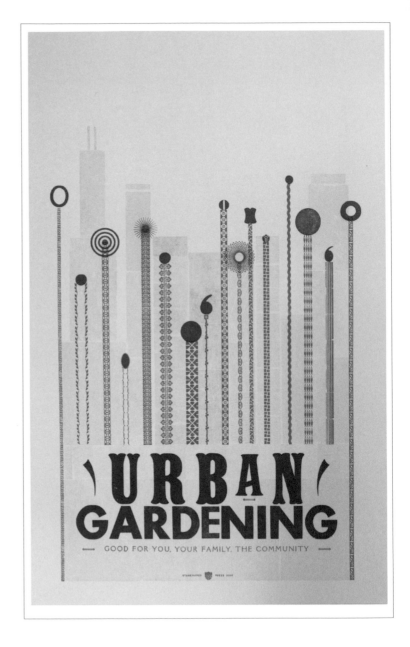

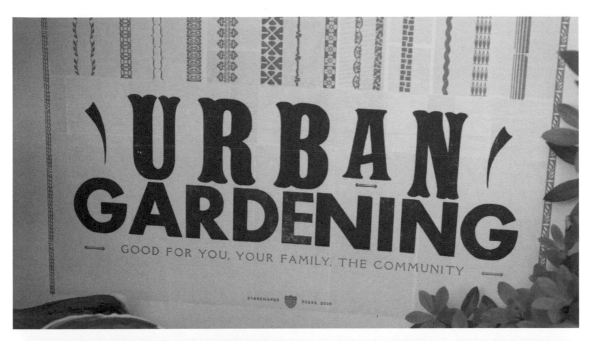

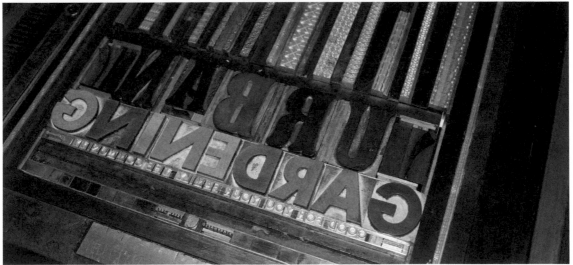

# Moontree
# Letterpress
## New York, New York, USA

Both of the Moontree Letterpress
pieces shown here were printed
using a Heidelberg Windmill
press. The Christmas ornaments
(top) feature various patterns and
were printed on scraps of Reich
Savoy 118lb cover stock. The print
(bottom) was created by illustrator
Cassidy Iwersen, and was inspired
by her dog Alfie. The artwork was
created in Illustrator before being
made into a photopolymer plate
ready for printing.

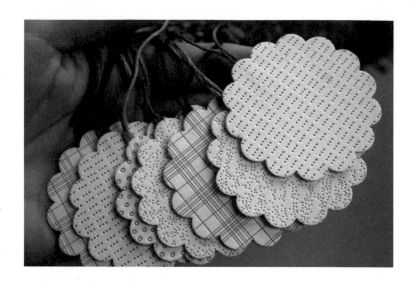

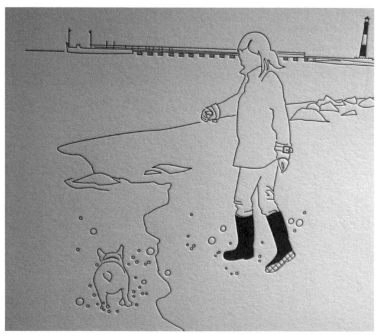

# Tallu-lah

## Sausalito, California, USA

This Mother's Day card was designed by Danielle Spinetta-Piche of
Tallu-lah and features calligraphy by Mo Seder. "Using both woodblock
and metal plates, my printer Leslie Prussia was able to meld modern
techniques with traditional printing methods," explains Spinetta-Piche.
The card was printed on an 1890 Challenge Gordon platen press built
in Chicago. Italian Fabriano paper stock was used together with Tiffany
Blue ink.

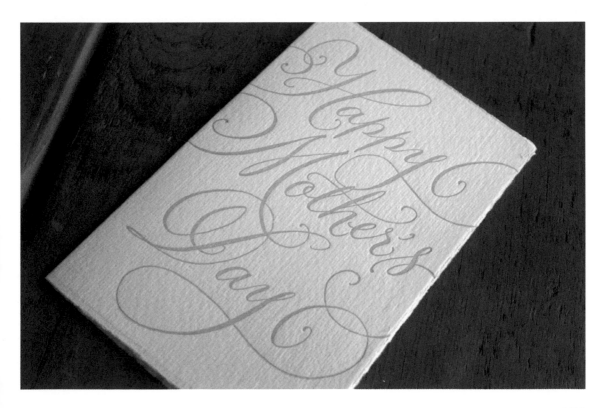

# Kishan Dhanak

Leicester, UK

This book was made for Kishan Dhanak's MA degree project at Central Saint Martins College of Art & Design in London. "I wanted to create a self-referential piece of design that explained the process of typesetting, so this book contains information for beginners to learn the core skills of typesetting—everything from what metal type is through to two-color printing." The book was printed on a Heidelberg Windmill press.

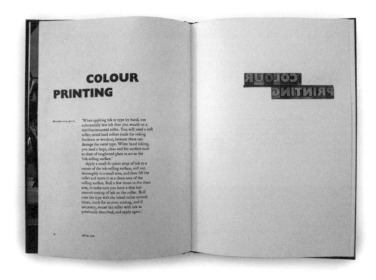

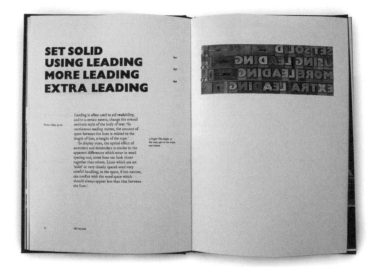

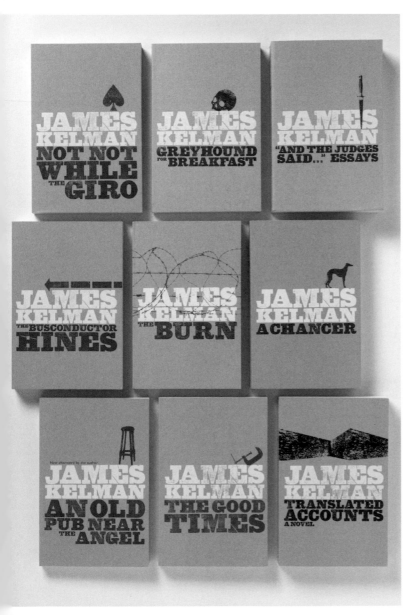

## Pentagram
London, UK

This series of covers was designed by Angus Hyland with Masumi Briozzo and was created for Polygon's series of James Kelman novels. The idea was to create a strong author brand identity that would link the books together. The Egyptian Bold Extended typeface was used across the cover designs, which came from Pentagram's woodblock collection. Specimen sheets were first created and scanned, and then the final result was achieved via a two-color litho printing process using GF Smith Colorplan stock, which was then stamped with matte white foil.

# Papermedium

New York, New York, USA

The cards shown here were designed by Sung Yoo of Papermedium.
Yoo begins by sketching her ideas, which she scans and converts into
vector art, and then has plates made for printing. All of the cards were
printed on a Vandercook Universal III press using Crane's Lettra
Fluorescent White cotton stock.

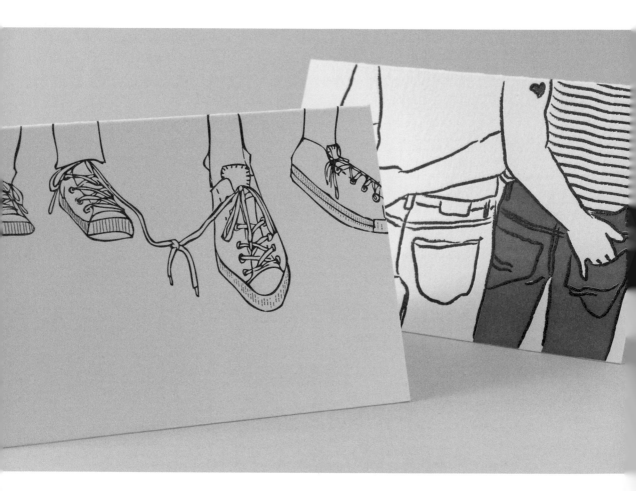

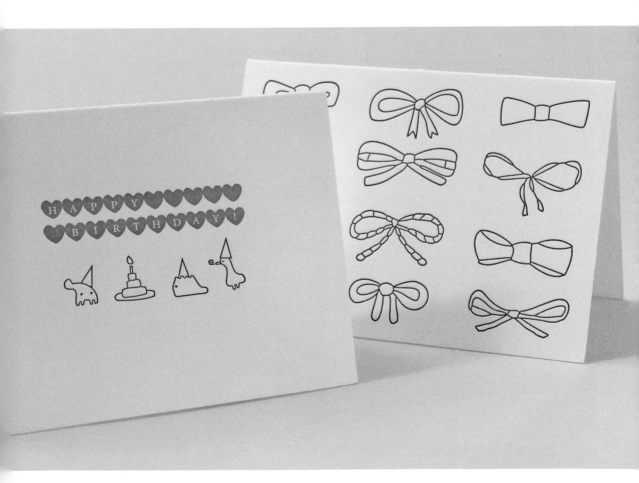

# Adam Ramerth / Studio on Fire

Minneapolis, Minnesota, USA

This wedding suite was created by designer Adam Ramerth and printed by Studio On Fire (see also pages 66–67), and is based on music and mixtapes. Ramerth took inspiration from the couple's shared love of music and a Run-DMC poster. "It was designed as a wedding gift for two of my very good friends," he explains. "There was no set criteria or style other than that they wanted it to be something that would capture the idea of their lives merging."

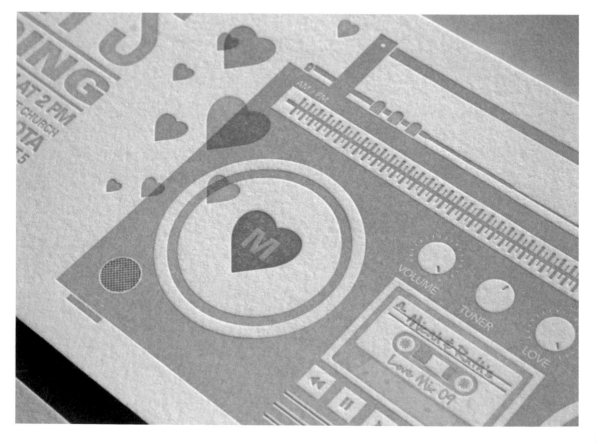

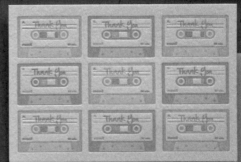

# Delphine Press
## Rancho Santa Fe, California, USA

Erika Firm of Delphine Press designed the pieces shown here. Decorative ironwork inspired the design for the wedding suite (top right and below), and wild yellow and orange California poppies inspired the imagery on the journal (far right, below). Firm sketched the designs, scanned them into Illustrator, and then transferred them to copper plates for printing. All of the Delphine Press pieces were printed on a Heidelberg press using soy-based inks.

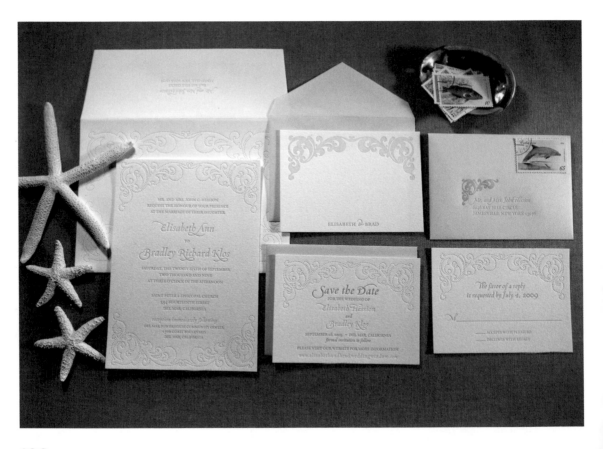

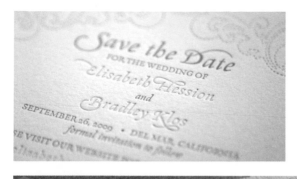

Save the Date
FOR THE WEDDING OF
*Elisabeth Hession*
*and*
*Bradley Klos*
SEPTEMBER 26, 2009 • DEL MAR, CALIFORNIA
*formal invitation to follow*
...SE VISIT OUR WEBSITE ...

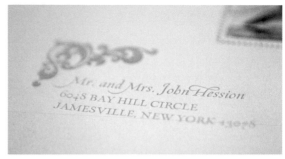

*Mr. and Mrs. John Hession*
6048 BAY HILL CIRCLE
JAMESVILLE, NEW YORK 13078

*Notes*

# Yukiko Sawabe
## Tokyo, Japan

Designer Yukiko Sawabe created
this Garamond poster for a type
exhibition. "At one time typefaces
would have been presented as
posters, and I wanted to return
to this idea. If you can touch the
letters directly you can better
understand typefaces and type
designers," explains Sawabe.
The poster was printed on
a rented letterpress machine
using a resin plate.

# Transfer Studio

London, UK

This set of boxed cards was created by Transfer Studio as a way of documenting its experience and learning of working with letterpress. "Our initial intention was to explore the traditional craft of typesetting and letterpress printing, without this necessarily concluding in a physical outcome. However, once this journey started we decided to document our learning process to share with fellow designers and people generally interested in letterpress," explains Falko Grentrup of Transfer Studio. The cards were printed on a Heidelberg Windmill press using oil-based inks.

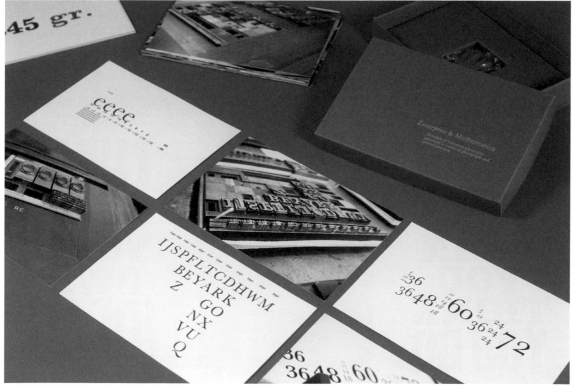

# Anthony Burrill

Kent, UK

Anthony Burrill is a UK-based designer known for his large woodblock prints. "All of my woodblock posters are set by Derrick at Adams of Rye print shop," explains Burrill. "I give him the text and a rough idea of layout and leave the rest up to him and his years of experience. We select the typeface that will best fill the space on the poster. I like to try and fit the largest possible type on the poster so that it has maximum impact." All of the posters were printed on a Heidelberg Windmill press using 100 percent recycled stock.

# A Two Pipe Problem

London, UK

Stephen Kenny at A Two Pipe Problem designed and printed the posters shown here. Describing the poster shown right, he says: "I created this poster as a way of trying to deal with not wanting to look at something, a morbid horror perhaps, and yet not being able to turn away." The poster is largely a result of experimenting with a variety of different wood type specimens. It was printed on an Adana press using textured testliner paper stock. The Cotard's poster (below and far right) was inspired by the look and feel of type specimen books. It was also printed on brown card stock using an Adana press.

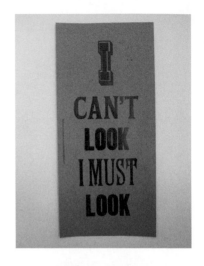

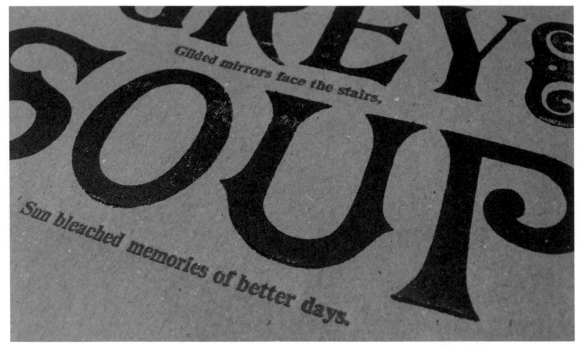

# COTARD'S

An overcoat hangs by the door,

# FAMILIAR

Dry ink stains on a faded page.

# GREY

Gilded mirrors face the stairs,

# SOUP

Sun bleached memories of better days.

Edition of 109. Issue 2 Stone Canyon Nocturne designed and printed by Stephen Kenny at www.stonepaperscissors.com

# Small Square Design

## San Francisco, California, USA

Basak Notz of Small Square Design created the spiral-bound journals shown here. The journal covers were printed on recycled chipboard, and recycled index paper was used for the interior pages. They were printed using rubber-based inks on a Chandler & Price press. The gift tag below was printed using the same press, with recycled kraft paper and rubber-based inks.

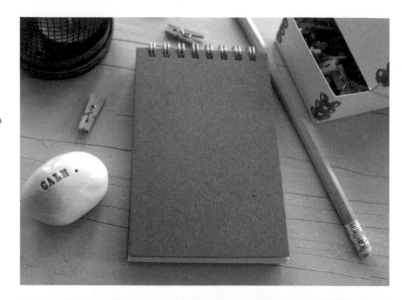

# This is Forest
## New York, New York, USA

Joel Speasmaker of This is Forest created this poster for the annual group exhibition Foodist Colony, a fundraiser benefiting the Central Virginia Foodbank. "The illustration on the poster is an abstract representation of space, the sun, the earth, nature, and our connection to it all," explains Speasmaker. The print was made at Swash Press in Seattle using a Chandler & Price press.

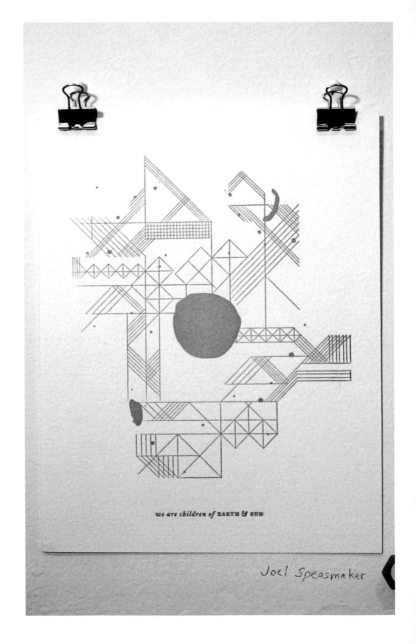

# Kayrock Screenprinting
## New York, New York, USA

The team at Kayrock Screenprinting designed this limited-edition print, which was inspired by old rubber horror masks and social and political issues in the United States. It was created in the run-up to Halloween and the U.S. presidential election. The monsters were hand-drawn, and the type was set in Illustrator before being printed out, distressed by hand, scanned, and made into photopolymer plates. It was printed on a Vandercook press using oil-based inks and Crane's Lettra stock.

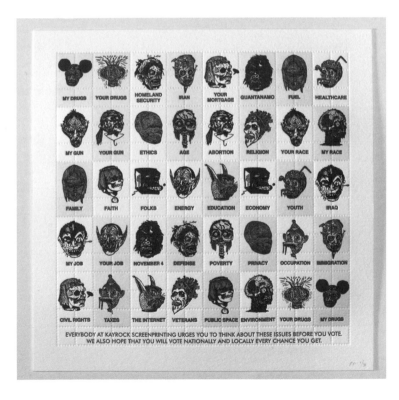

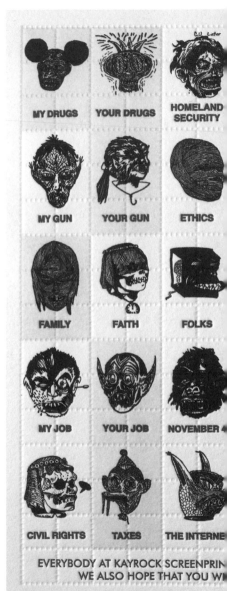

# Blue Ribbon Design
New York,
New York, USA

This notebook was created by
Kimberly Driessen for Blue
Ribbon Design's wholesale line.
"We wanted to design a small
notebook for jotting down lists
and notes—the small size, 6 x
4¼in (15.24 x 41.8cm), is perfect
for stashing in a purse," explains
Driessen. French embroideries
from the 1920s inspired the
original artwork, and the cover
was printed using photopolymer
plates on a Heidelberg Windmill
press with soy-based inks and
Strathmore cover stock.

# Erika Ebert Press
## Philadelphia, Pennsylvania, USA

Erika Ebert designed the wedding suite shown here for a couple living
in Philadelphia. Many of the invitations were going to be sent overseas,
so the clients wanted to show the historic qualities of Philadelphia. "It was
as if their guests were receiving a document that could have been printed
in the time of Benjamin Franklin," explains Ebert. Most of the images
featured on the invites were found in books from the 1800s and 1900s.
The suite was printed on a Chandler & Price press using hand-mixed,
oil-based inks.

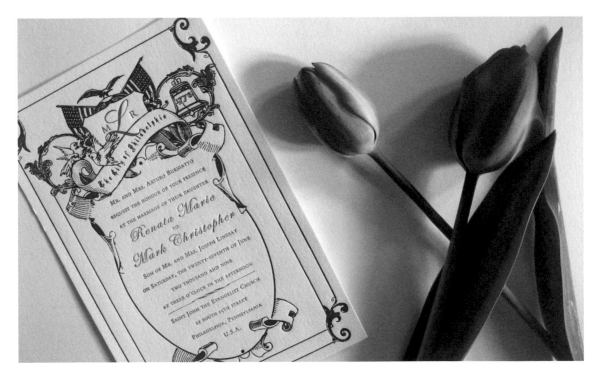

# Kimberly Austin Press

## San Francisco, California, USA

Kimberly Austin used oil-based inks and a Chandler & Price press with a Boxcar Base to print the pieces featured here. The design for the wedding invitation (below) was inspired by the clients' love of travel, and each was finished off with Japanese tissue paper and vintage string. The simple floral pattern featured on the stationery set (right) came from an antique book of French embroidery patterns that Austin scanned, edited, and converted for printing.

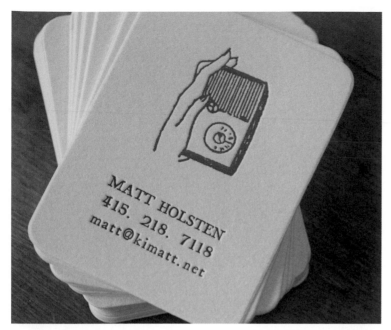

Austin also created the business cards (left) by scanning and editing images found in catalogs. The cards were printed on scraps of Crane's Lettra cotton stock. The wedding set (below) features a theater-like typeface set in black and gold, and was printed on ivory museum board.

MATT HOLSTEN
415. 218. 7118
matt@kimatt.net

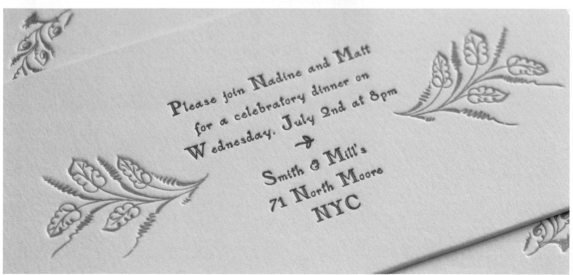

Please join Nadine and Matt
for a celebratory dinner on
Wednesday, July 2nd at 8pm
→
Smith & Mill's
71 North Moore
NYC

# Fugu
# Fugu Press

Pasadena,
California, USA

The cards shown here were illustrated by Fugu Fugu Press cofounder Shino Charlson and printed by Ken Charlson. The card (right) was illustrated by hand and then scanned into Illustrator and transferred to a photopolymer plate. Shino created the Father's Day card (center right) using an original illustration. She explains: "We printed the log first with a deep impression, and the bears afterwards with a lighter impression." The I'm Sorry card (far right) was printed on post-consumer waste (PCW) recycled stock. Shino explains: "We wanted a blue that had just enough weight to be noticed, but still felt light. The one we chose works well with the yellowish-brown of the illustrated figure." The cards were printed on a Heidelberg Windmill press using soy-based inks.

154

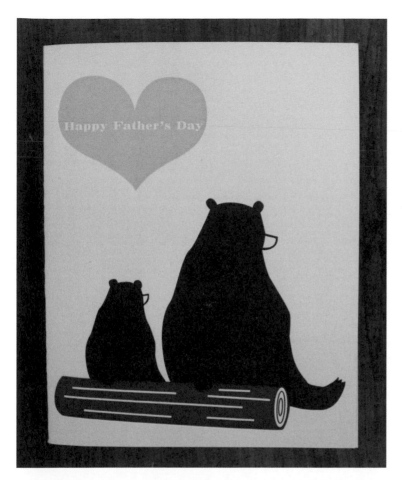

Happy Father's Day

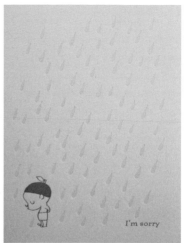

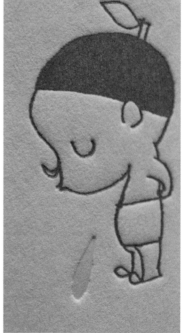

I'm sorry

155

## On Paper Wings
### Springfield, Missouri, USA

Doug Wilson of On Paper Wings created the posters shown here as part of a series of prints inspired by various phrases and maxims he finds interesting. The first (right) was printed in a limited edition of 90 using a Vandercook No. 4 press and black ink on French Paper Company 100lb Berrylicious paper. The second (below) was printed in a limited edition of 85 using metallic silver ink on wine-colored French Paper Company 100lb cover weight Speckletone paper. The poster (far right) features antique wood type from John Horn of Shooting Star Press's collection, and the images are metal engravings collected from old print shops. The poster was printed in red ink on tan-colored French Paper Company 80lb Speckletone card stock.

KEEP IT SIMPLE STUPID.

DO WHAT YOU LOVE, LOVE WHAT YOU DO.

Wood type printed by Douglas Wilson on a Vandercook Proof Press

# Product Superior

New York,
New York, USA

John Earles and Jennifer Blanco of Product Superior designed the cards featured here. Describing the moving card below, Blanco says: "Whether relocating cross-country or a few blocks over in a city like New York, we found the image of a huge truck a charming way to deliver this message." The postcard shown right references iconic cruise liners from the 1930s and 1940s. The ship was hand-drawn and the banner set in a script-style font. Both cards were printed on recycled stock with vegetable and oil-based inks using a Heidelberg Automatic press with magnesium plates.

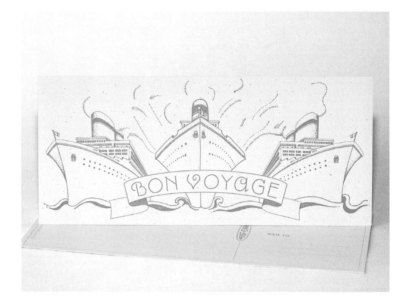

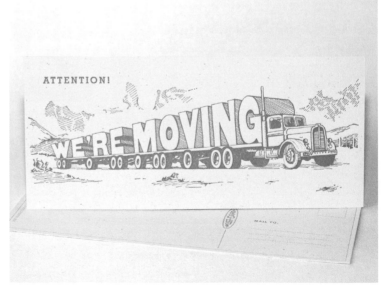

# Eva Hudakova

London, UK

Inspired by markets—their atmosphere, character, sounds, and colors—
Eva Hudakova created this poster while in her final year at the London
College of Communication. The project focuses on representing sounds
from Petticoat Lane market in London, and the outcome is this large
print consisting of wood and metal type. Sentences are positioned in
a similar way to the layout of a market, and the size and variety of typefaces
represent the different voices of the traders, with the chosen ink colors
referencing what they sell.

# Chewing the Cud

## San Francisco, California, USA

The series of cards shown below was created as a way to have fun
with puns, typography, and vintage found illustrations. The wedding
suite shown below right was created for a couple who were childhood
sweethearts. Viola Sutanto of Chewing the Cud found inspiration in
lined notebooks and notes passed between children in class. All of
the pieces were printed on a Chandler & Price press using soy-based
inks and 100 percent recycled stock.

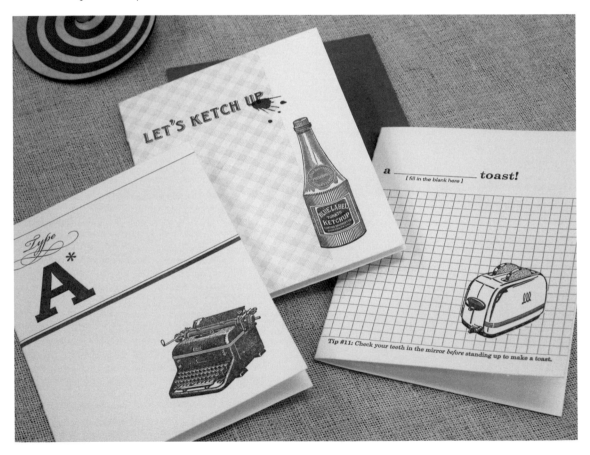

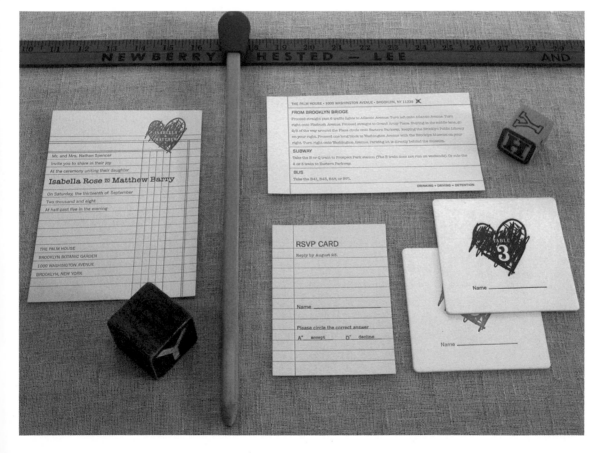

NEWBERRY — HESTED — LEE AND

**THE PALM HOUSE • 1000 WASHINGTON AVENUE • BROOKLYN, NY 11225**

**FROM BROOKLYN BRIDGE**
Proceed straight past 6 traffic lights to Atlantic Avenue. Turn left onto Atlantic Avenue. Turn right onto Flatbush Avenue. Proceed straight to Grand Army Plaza. Staying in the middle lane, go 2/3 of the way around the Plaza circle onto Eastern Parkway, keeping the Brooklyn Public Library on your right. Proceed one long block to Washington Avenue with the Brooklyn Museum on your right. Turn right onto Washington Avenue. Parking lot is directly behind the museum.

**SUBWAY**
Take the B or Q train to Prospect Park station (The B train does not run on weekends). Or ride the 2 or 3 train to Eastern Parkway.

**BUS**
Take the B41, B43, B48, or B71.

DRINKING • DRIVING • DETENTION

Mr. and Mrs. Nathan Spencer

Invite you to share in their joy

At the ceremony uniting their daughter

**Isabella Rose** ∞ **Matthew Barry**

On Saturday, the thirteenth of September

Two thousand and eight

At half-past five in the evening

THE PALM HOUSE

BROOKLYN BOTANIC GARDEN

1000 WASHINGTON AVENUE

BROOKLYN, NEW YORK

**RSVP CARD**
Reply by August 25.

Name

Please circle the correct answer

A* accept          D" decline

TABLE 3

Name

Name

# Greenwich Letterpress

New York, New York, USA

Amy Salvini-Swanson of Greenwich Letterpress designed the cards featured here. Describing the card below left, she says: "I was inspired to create this card by a *Jaws* marathon playing on TV." The illustration was hand-drawn by Greenwich Letterpress co-owner Beth Salvini. The card shown below center is part of a series inspired by New York City, and the thank-you card (right) was inspired by old Victorian etchings. Each piece was printed on a Heidelberg Windmill press using metal plates with soy-based inks on Crane's Lettra 100 percent cotton stock.

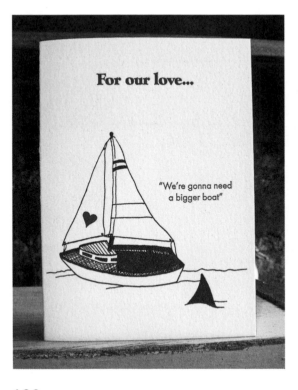

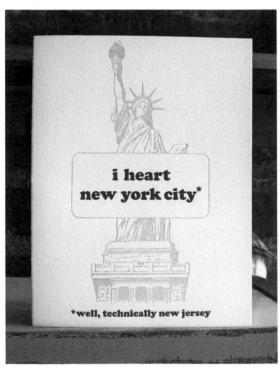

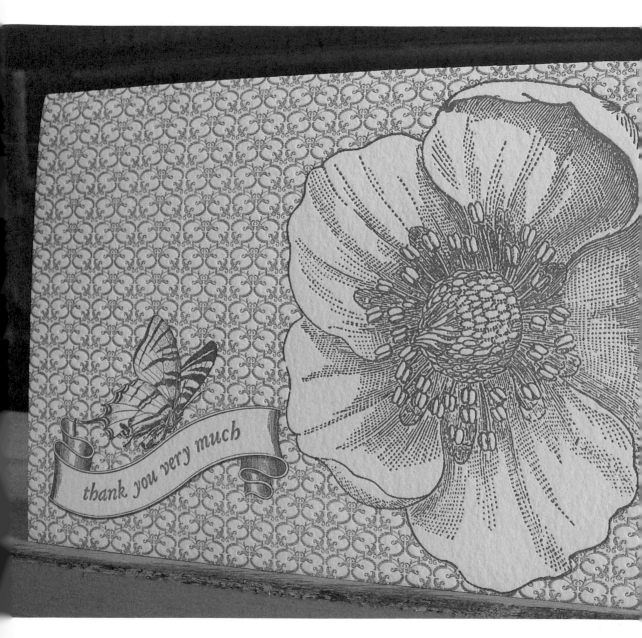

thank you very much

# Good on Paper /
# Paper Monkey Press

## Berkeley, California / Pittsburgh, Pennsylvania, USA

The wedding suite and birthday invitation shown here were designed
by Good on Paper and printed by Paper Monkey Press. The wedding
suite (right and below) was inspired by French chinoiserie and combines
whimsical birds and lemon yellows. The birds were illustrated by hand,
and the patterns were taken from a Victorian pattern book, and everything
was put together in Illustrator. The sixtieth birthday invitation (far right)
was inspired by the birthday girl's move from Wisconsin to California.
Both pieces were printed on a Chandler & Price press using Crane's
Lettra stock.

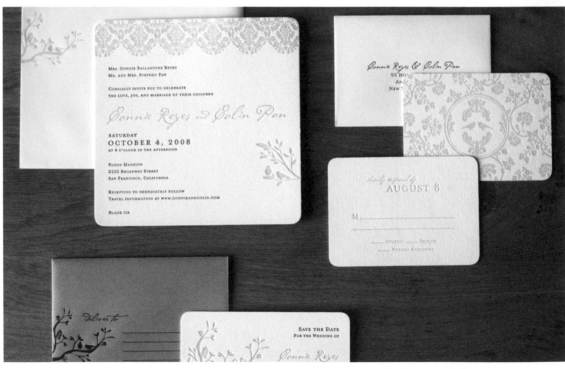

**60** Join us to celebrate *fabulous years* of
JAN ROYER LEIGHT

**WHEN**
July 24 and 25

**WHERE**
Resort at Pelican Hill
_____ Road South

KINDLY RESPOND BY
JULY *7th*

RSVP

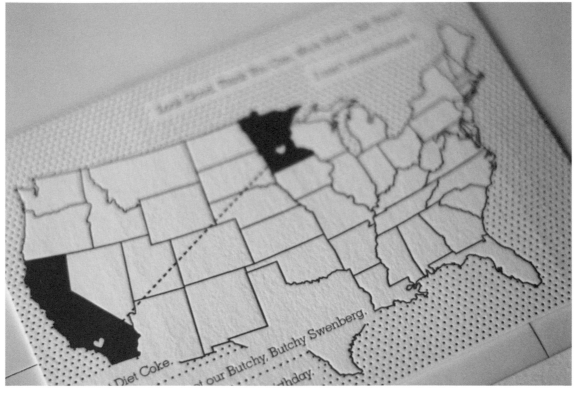

... Diet Coke. ... d our Butchy, Butchy Swenberg.

# Snap & Tumble
## Toronto, Ontario, Canada

Tanya Roberts of Snap & Tumble is a big fan of snail mail and encourages writing cards or letters to friends as opposed to e-mails. For the two cards shown far right, she printed typical handwritten greetings using large lead vintage woodblock type on Crane's Lettra Fluorescent White cotton stock. The card below was printed using an Adana 8 x 5 press with Pantone Reflex Blue Van Son rubber-based ink on Crane's Lettra Fluorescent White stock. The journal cover shown right was printed on remnant paper from old misprinted letterpress projects.

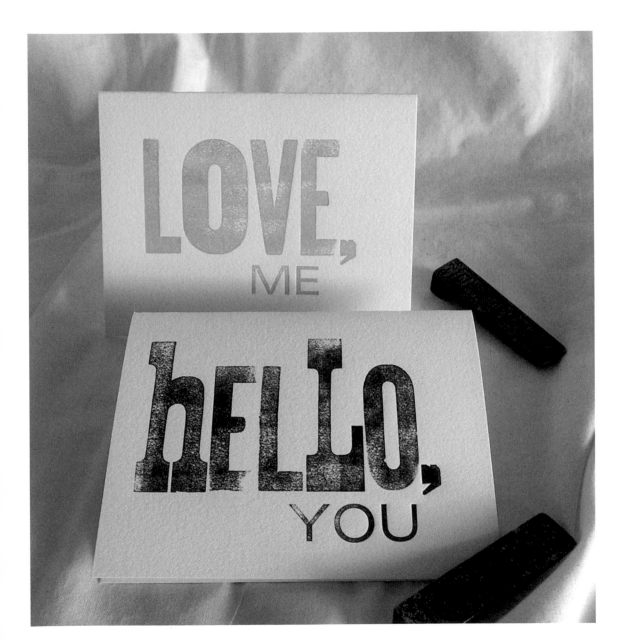

# Jacqueline Ford
## London, UK

Jacqueline Ford created this piece
as part of the Type Specimen
Project at the London College
of Communication's letterpress
workshop. Describing the tiger
print, Ford explains: "The brief
was to create a type specimen
sheet for one of the typefaces in
the workshop, and I chose border
patterns." She looked at cross-
stitch patterns, pixels, and
halftones to create graphic posters
that comprise small entities.

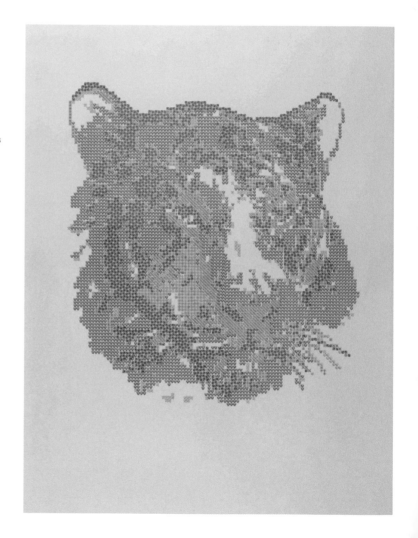

# Salt & Syrup
## Stockholm, Sweden

"Combining my love of children's illustration, minimialism, and Swedish modernism, I decided to create a collection of notecards that would cater to children and adults," explains Emily Ranneby of Salt & Syrup. "I wanted the debut collection to be both playful and sweet, while combining highly stylized illustrations with an unexpected use of Swedish, English, and French languages." The illustrations were originally created in Illustrator, and the cards were printed on a Heidelberg Windmill press using vegetable oil-based inks and Mohawk Superfine stock.

# Megan Adie

Oakland, California, USA

Megan Adie created this calendar, which features drawings of 12 different swimming pools from around the world, including the Sutro Baths in San Francisco, the pool from the Lalu Hotel at Sun Moon Lake in Taiwan, and the Tinside Lido in Plymouth, UK. The entire calendar was printed using polymer plates on a Vandercook press.

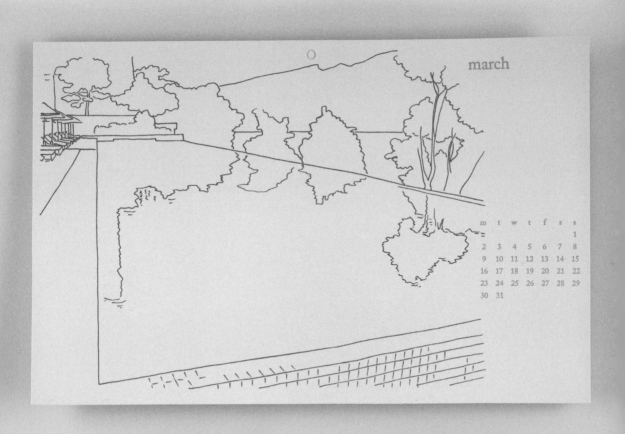

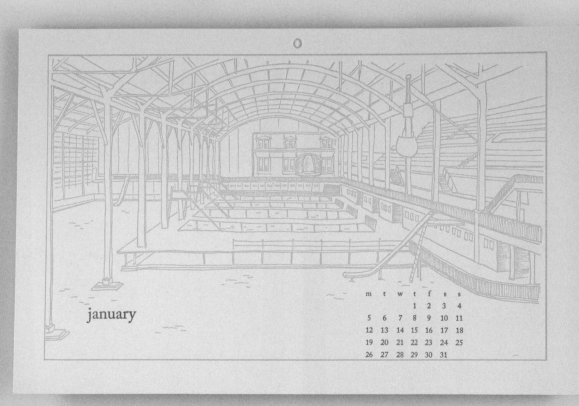

january

| m | t | w | t | f | s | s |
|---|---|---|---|---|---|---|
| | | | | 1 | 2 | 3 | 4 |
| 5 | 6 | 7 | 8 | 9 | 10 | 11 |
| 12 | 13 | 14 | 15 | 16 | 17 | 18 |
| 19 | 20 | 21 | 22 | 23 | 24 | 25 |
| 26 | 27 | 28 | 29 | 30 | 31 | |

# M Press Studio

## Los Angeles, California, USA

This calendar is the result of a collaboration between illustrator
Christine Castro Hughes and designer and printer Maria Villar at
M Press Studio. The calendar is divided by seasons, with each page
featuring three months. Each hand-drawn illustration was made into
a digital file, which was then turned into a plate ready for printing
on a Chandler & Price press using Classic Crest paper stock.

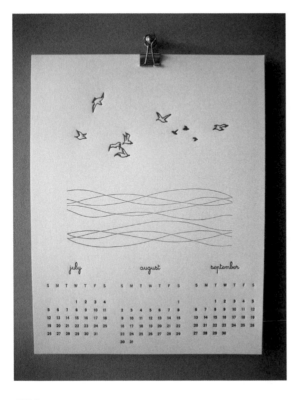
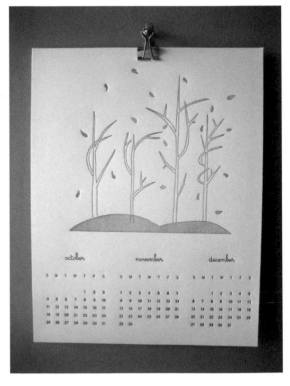

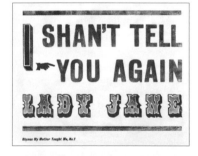

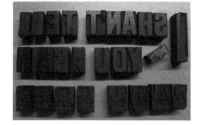

## The Hi-Artz Press
Luton, UK

The poster shown left was designed by Helen Ingham of The Hi-Artz Press to promote an informal acoustic jam session held in a traditional English pub. The poster below is part of a series of self-initiated pieces featuring sayings Ingham remembers from her childhood. It was printed on a Vandercook No. 4 proof press using Van Son oil-based inks and newsprint stock.

# Hijirik Studio
## New York, New York, USA

Hijiri K. Shepherd of Hijirik Studio created the print shown below. "The phrase 'live what you love' has been my inspiration; it's always been in my head, so when I had an opportunity to work with beautiful vintage wood type for the first time this was what I chose to print," she explains. It was printed on a Vandercook Universal I press using soy-based ink and Crane's Lettra Pearl White stock. The alphabet greeting cards (far right) were created for different occasions and combine a mix of different digital and handmade elements.

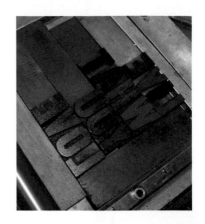

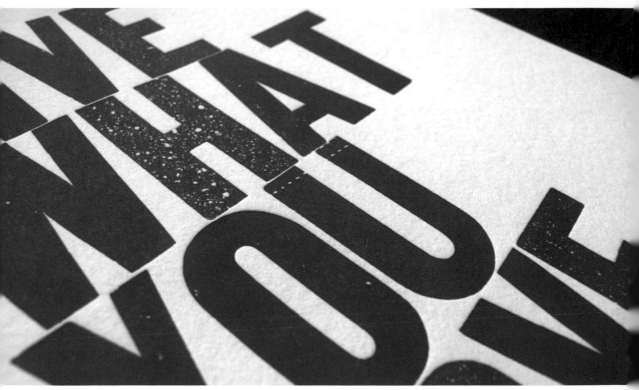

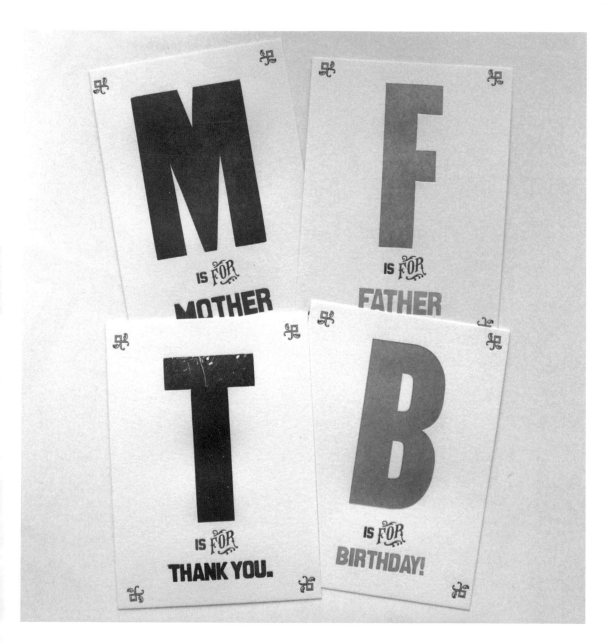

# Pink Dot Press
## Coronado, California, USA

This wedding set was created for a couple who wanted something decadent, young, and fun. To this end, the designers at Pink Dot Press created a ruby crystal-embellished invitation. A bold damask pattern was used on each piece, with different elements incorporated into the separate pieces. The set was printed on a Chandler & Price press using oil-based inks and 100 percent cotton paper.

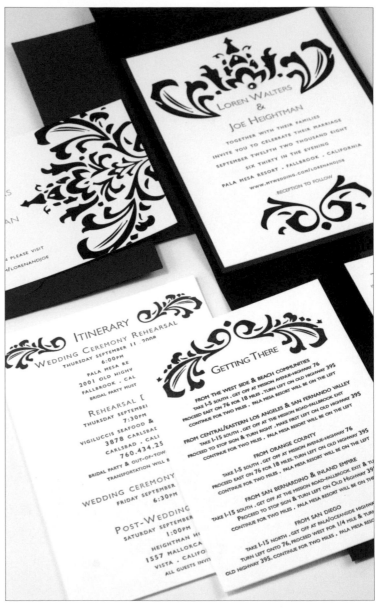

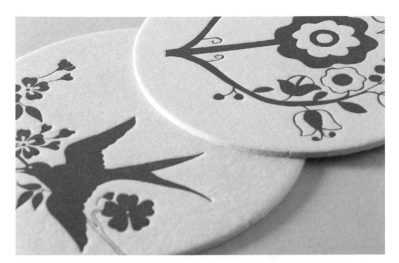

# 12fifteen
Stamford,
Connecticut, USA

Johanna Anderes of 12fifteen
designed these coasters. The
artwork was created in Illustrator
and was inspired by spring, forests,
and 1960s Scandinavian design.
Each was printed on a Chandler
& Price press using photopolymer
and magnesium plates, rubber-
based inks, and heavy 100 percent
cotton coaster stock.

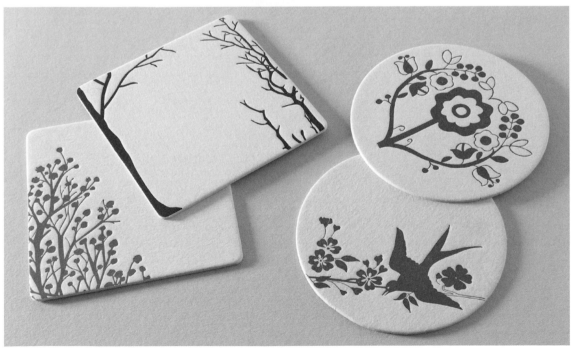

# Letteria
## Zweidlen, Switzerland

Shown here is the work of Swiss designer and printer Letteria. Each piece was printed using hand-mixed inks. The coasters (right) were created for a special event in a small shop and feature vintage wood type. The snowflake coasters (below) were created for Letteria's winter line, and a repeat snowflake pattern was designed digitally and then printed onto the coasters. The heart cards (top far right) were created for Valentine's Day and were made using hand-mixed pink, rose, and red inks. The bird tags (below right and below far right) were created for use on gifts or as table decorations.

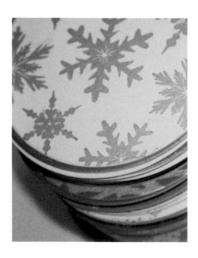

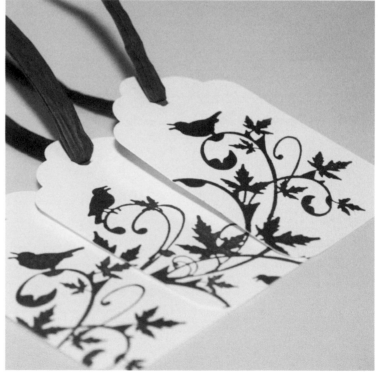

# Lucky Bee Press
## Santa Cruz, California and Madison, Wisconsin, USA

Laurie Okamura and Amy Stocklein of Lucky Bee Press wanted to create a fun and cheery card line with a vintage flair. The results are the bird cards shown right and below. Okamura hand-drew the images and then scanned them to create printable artwork. The illustrated hang tags shown far right also feature original hand-drawn illustrations and can be used in a variety of different ways. All of the Lucky Bee pieces were printed on a Chandler & Price press using hand-mixed, oil-based inks.

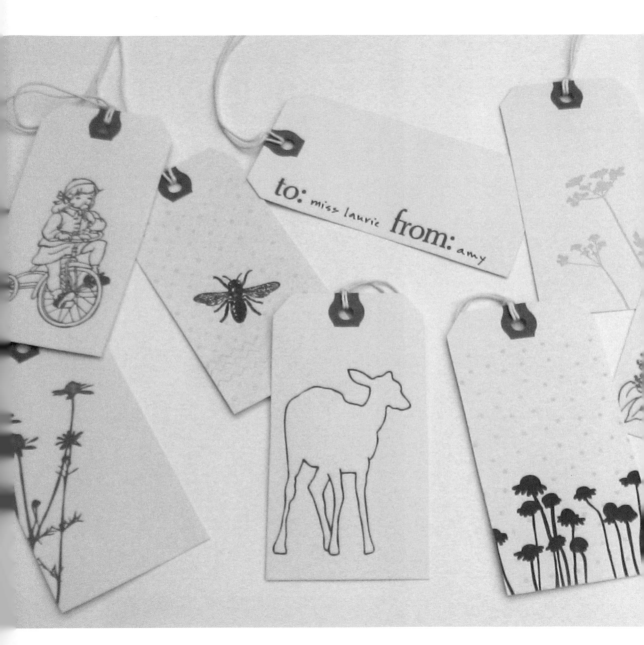

to: miss laurie from: amy

# Oddball Press / Rohner Letterpress

Cleveland, Ohio /
Chicago, Illinois, USA

The poster shown right features an illustrated alphabet and was created by Kati Hanimagi of Oddball Press. The illustrations are a combination of found images and the designer's own hand-drawn illustrations, which were scanned and collaged together using Illustrator and Photoshop. The calendar (center) is part of Oddball Press's Natural Disaster line. "The concept was inspired by a school science fair project magnified to grand destruction scale," explains Hanimagi. The images are a combination of found illustrations and Hanimagi's hand-drawn illustrations, which were scanned and collaged together in Illustrator and Photoshop. The numbers poster (far right) was inspired by a cheerleading pyramid and circus grand finales. Each item was printed by Rohner Letterpress (see also pages 28 and 84–85) using a Heidelberg Cylinder press and vegetable-based inks.

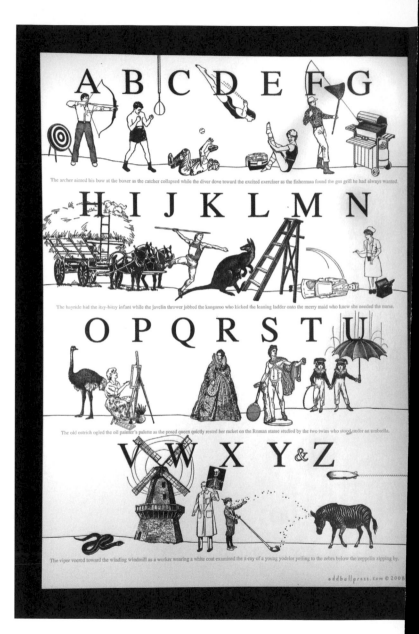

JANUARY 2009

| SUN | MON | TUE | WED | THU | FRI | SAT |
|-----|-----|-----|-----|-----|-----|-----|
|     |     |     |     | 1   | 2   | 3   |
| 4   | 5   | 6   | 7   | 8   | 9   | 10  |
| 11  | 12  | 13  | 14  | 15  | 16  | 17  |
| 18  | 19  | 20  | 21  | 22  | 23  | 24  |
| 25  | 26  | 27  | 28  | 29  | 30  | 31  |

# Resources

## General Resources

Amalgamated Printers' Association
  www.apa-letterpress.com

American Amateur Press Association
(AAPA): Resources for Letterpress Printers
  www.aapainfo.org/lpress.html

Briar Press
  www.briarpress.org

British Letterpress
  britishletterpress.co.uk

Christchurch Letterpress
  www.letterpress.org.nz

College & University Letterpress Printers' Association
  www.collegeletterpress.org

Five Roses: Introduction to Letterpress Printing
  www.fiveroses.org/intro.htm

Flurry Journal
  www.flurryjournal.com

I Love Letterpress
  www.iloveletterpress.com

Letterpress Alive
  www.letterpressalive.co.uk

Letterpress Type
  www.letterpresstype.com

PPLetterpress Forum
  groups.yahoo.com/group/PPLetterpress

## Groups

American Printing History Association
  www.printinghistory.org

British Printing Society
  www.bpsnet.org.uk

Canadian Bookbinders and Book Artists Guild
  www.cbbag.ca

Fine Press Book Association
  www.fpba.com

The National Amateur Press Association
  www.amateurpress.org

Printing Historical Society
  www.printinghistoricalsociety.org.uk

The Society of Typographic Aficionados (SOTA)
  www.typesociety.org

The United Amateur Press Association of America
  uapaa.jarday.com

## Type

AAPA Foundry List
  www.aapainfo.org/lpress.html#foundries

Australian Type Company
  home.vicnet.net.au/~typo/austype/~austype.htm

Dale Guild Type Foundry
  www.daleguild.com

M & H Type
  www.arionpress.com/mandh

Michael & Winifred Bixler
  www.mwbixler.com

Sterling Type Foundry
  www.sterlingtype.com

## International Museums

AAPA Printing Museums List
www.aapainfo.org/museums.html

Association Lettres et Images (Switzerland)
www.letterpress.ch

Gutenberg-Museum Mainz (Germany)
www.gutenberg-museum.de

Hamilton Wood Type & Printing Museum (Wisconsin)
www.woodtype.org

The International Printing Museum (California)
www.printmuseum.org

Melbourne Museum of Printing (Australia)
www.mmop.org.au

Museum Plantin-Moretus (Belgium)
museum.antwerpen.be/plantin_Moretus/index_eng.html

The Museum of Printing (Massachusetts)
www.museumofprinting.org

Museum of Printing History (Texas)
www.printingmuseum.org

The Robert C. Williams Paper Museum (Georgia)
www.ipst.gatech.edu/amp

## Equipment

Boxcar Press
www.boxcarpress.com

Brandtjen & Kluge, Inc.
www.kluge.biz

Briar Press Museum of Printing Presses
www.briarpress.org/museum

Crane's Lettra Letterpress Paper
www.neenahpaper.com/cranepaper/lettra/home.html

Don Black Linecasting Ltd.
www.donblack.ca

Golding Printing Presses
www.aapainfo.org/golding

Letterpress Manuals
www.petrzelka.com/Site/Letterpress_Manauls.html

Letterpress Services
www.letterpressservices.com

NA Graphics
www.nagraph.com

Photopolymer Plates
www.photopolymerplates.com

Vandercook Press
www.vandercookpress.info

# Contact Details

12fifteen
www.12fifteen.com

A Two Pipe Problem
www.atwopipeproblem.com

Adam Ramerth
priceofdesign.blogspot.com

Albertine Press
www.albertinepress.com

Allie Munroe
www.alliemunroe.com

Angela Ligouri
www.angelaliguori.com

Anthony Burrill
www.anthonyburrill.com

Armina Ghazaryan
www.armina.info

BirdDog Press
www.birddogpress.com

Bittersugar
www.bittersugar.etsy.com

Blackbird Letterpress
www.blackbirdletterpress.com

Blue Ribbon Design
www.blueribbondesign.com

Carrot & Stick Press
www.carrotandstickpress.com

Chewing the Cud
www.chewingthecud.com

Clementine Press
www.clementinepress.blogspot.com

Cranky Pressman
www.crankypressman.com

Dawn Hylon Lucas (hyC creative)
www.dawnhylonlucas.com
www.hyccreative.etsy.com

Dee & Lala
www.deeandlala.com

Delphine Press
www.delphinepress.com

Dolce Press
www.dolcepress.com

Dutch Door Press
www.dutchdoorpress.com

DWRI Letterpress
www.dwriletterpress.net

Egg Press
www.eggpress.com

Ella Studio
www.ella-studio.com

Eric Eng Design
www.ericeng.com

Erika Ebert Press
www.erikaebertpress.com

Eva Hudakova
www.evahudakovadesign.co.uk

Flora and Fauna Press
www.floraandfaunapress.com

Fugu Fugu Press
www.fugufugupress.com

Full Circle Press
www.full-circle-press.com

Function Matters
www.functionmatters.com

Gavillet & Rust
www.gavillet-rust.com

Gilah Press + Design
www.gilahpress.com

Good on Paper
www.goodonpaperdesign.com

Goosefish Press
www.goosefishpress.com

Greenwich Letterpress
www.greenwichletterpress.com

Hammerpress
www.hammerpress.net

Hand & Eye Letterpress
www.handandeye.co.uk

Harrington&Squires
www.harringtonandsquires.co.uk

Hello!Lucky
www.hellolucky.com

The Hi-Artz Press
www.hi-artz.co.uk

Hijirik Studio
www.hijirik.com

Horwinksi Printing
www.horwinski.com

Ice Cream Social
www.icecreamsocialshoppe.com

Inky Lips Press
www.inkylipspress.com

Jackson Creek Press
www.jacksoncreekpress.ca

Jacqueline Ford
www.jacquelineford.co.uk

Jane Hancock Papers
www.jhpapers.com

Jens Jørgen Hansen
bogtrykkeren.etsy.com

Kayrock Screenprinting
www.kayrock.org

Kimberly Austin Press
www.austin-press.com

Kishan Dhanak
www.kishandhanak.co.uk

Letteria
www.letteria.ch

Letterpress Delicacies
www.letterpressdelicacies.com

Letters Lubell
www.letterslubell.com

Linda & Harriett
www.lindaandharriett.com

Lucky Bee Press
luckybeepress.etsy.com

Lucky Star Press
www.luckystarpress.com

M Press Studio
www.mpresstudio.com

The Mandate Press
www.themandatepress.com

Matthew Kelsey
www.mkprinter.com

May Day Studio
www.maydaystudio.com

Megan Adie
www.meganadie.com

Megan Creates
www.megancreates.com

Messenger Bird Press
www.messengerbirdpress.com

Moontree Letterpress
www.moontreepress.com

Oddball Press
www.oddballpress.com

Old School Stationers
www.oldschoolstationers.com

Olive-Route
www.olive-route.com

On Kamal
www.onkamal.com

On Paper Wings
www.onpaperwings.com

Pancake & Franks
www.pancakeandfranks.com

Papermedium
www.papermedium.com

Paper Monkey Press
www.papermonkeypress.com

The Paper Thieves
www.thepaperthieves.blogspot.com

Pearl & Marmalade
www.pearlmarmalade.com

Pentagram
www.pentagram.com

Pink Dot Press
www.pinkdotpress.com

Poppy Letterpress
www.poppyletterpress.com.au

Product Superior
www.productsuperior.com

Rohner Letterpress
www.rohnerletterpress.com

Ross MacDonald
www.ross-macdonald.com

Ruby Victoria
www.rubyvictoria.blogspot.com

Salt & Syrup
www.saltsyrup.com

Sarah Drake Design
www.sarahdrakedesign.com

Satsuma Press
www.satsumapress.com

Scott King
www.scottking.co.uk

SeeSaw Designs
www.seesawdesigns.com

Sergi Diaz
sergi.diaz@gmail.com

Sesame Letterpress
www.sesameletterpress.com

SimpleSong
www.simplesongdesign.com

Skin Designstudio
www.skin.no

Small Square Design
www.smallsquaredesign.com

Smock
www.smockpaper.com

Snap & Tumble
www.snapandtumble.com

Snow & Graham
www.snowandgraham.com

Starshaped Press
www.starshaped.com

Studio 204 (Virgil Scott)
vmscott@sbcglobal.net
www.flickr.com/photos/204studio

Studio Olivine
www.studio-olivine.com

Studio on Fire
www.studioonfire.com
www.beastpieces.com

Sweetbeets
www.sweetbeets.com

Sycamore Street Press
www.sycamorestreetpress.com

Tallu-lah
www.tallu-lah.com

This is Forest
www.thisisforest.com

Thoughtful Day
www.thoughtfulday.com

Tiny Pine Press
www.tinypinepress.com

Transfer Studio
www.transferstudio.co.uk

Truly Smitten
www.trulysmitten.com

Twig & Fig
www.twigandfig.com

Typoretum
www.typoretum.co.uk

Yee-Haw Industries
www.yeehawindustries.com

Yukiko Sawabe
temppress.blogspot.com

# Photography Credits

# Index

## Acknowledgments

I greatly enjoyed researching and writing this book.
Receiving package upon package of beautiful letterpress
work for some months was a real pleasure. I'd like to
thank all of the designers and studios around the world
that contributed work and made this book happen. Thank
you also to the team at RotoVision for their continued
editorial and design support, and a special thanks to
Yee-Haw Industries for writing the book's foreword.

This book is for Mum and for Daniel.

## Author Biography

Charlotte Rivers is a freelance
writer and contributor to a
number of international design
magazines. She is the author
of several RotoVision books
including *Maximalism*, *CD-Art*,
and *Poster-Art*.

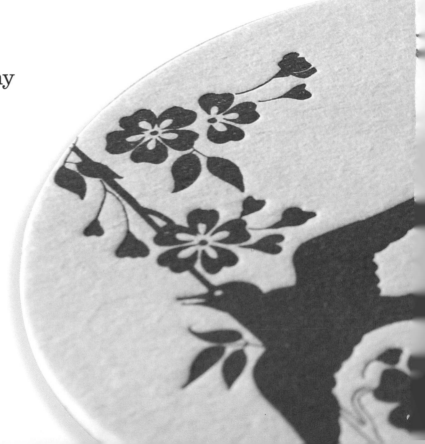